The Postcard History Series

Big Moose Lake
New York
in Vintage Postcards

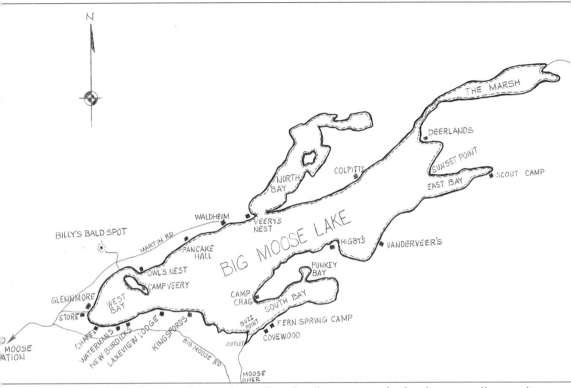

This map, drawn by one of the authors, identifies the camps and other locations illustrated in this book. The steamboat's daily journey commenced at the Glennmore and progressed counterclockwise around the lake. The chapters in this book have been arranged similarly.

THE POSTCARD HISTORY SERIES

Big Moose Lake
NEW YORK
IN VINTAGE POSTCARDS

William L. Scheffler and Frank Carey

ARCADIA

Copyright © 2000 by William L. Scheffler and Frank Carey.
ISBN 0-7385-0411-4

First printed in 2000.
Reprinted in 2000.

Published by Arcadia Publishing,
an imprint of Tempus Publishing, Inc.
2 Cumberland Street
Charleston, SC 29401

Printed in Great Britain.

Library of Congress Catalog Card Number: 00-106410.

For all general information contact Arcadia Publishing at:
Telephone 843-853-2070
Fax 843-853-0044
E-Mail sales@arcadiapublishing.com

For customer service and orders:
Toll-Free 1-888-313-2665

Visit us on the internet at http://www.arcadiapublishing.com

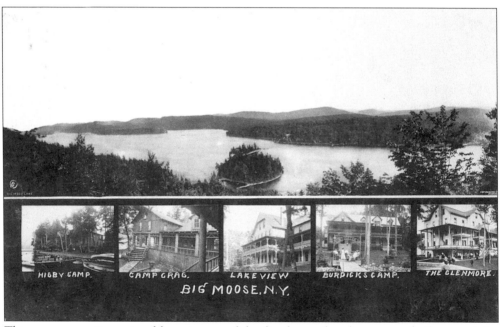

This rare composite postcard has pictures of the five largest hotel structures built around the lake. In the year 2000, only one of the five, Burdick's, survives as a hotel; Lake View is privately owned; the other three buildings have been destroyed.

Contents

Acknowledgments		6
Introduction		7
1.	Big Moose Station, Ainsworth's, and the Road to the Lake	9
2.	The Glennmore and the Big Moose Supply Company	21
3.	The Chapel and Burdick's	33
4.	Lake View Lodge	43
5.	Continuing along the South Shore	59
6.	Higby Camp	77
7.	From VanderVeer's to North Bay	97
8.	Brown's to Martin's	105
9.	Returning to the Landing, Odd Lots	119

ACKNOWLEDGMENTS

To the people who shared their stories and knowledge of Big Moose history with us—Wanda Kinne Martin, Francis E. Carey Sr., and Bill Dunn—we extend our heartfelt thanks.

The authors thank the many Big Moose residents and guests who seek to preserve the history of the lake by organizing the Big Moose History Project; their encouragement of our efforts is greatly appreciated.

For having discovered Big Moose Lake for themselves so many years ago and for introducing succeeding generations of their families to its beauty and wonder, we acknowledge Edward O. Stanley, Marjorie Stanley Carey, Harriet Bentley, and Len and Bee Scheffler.

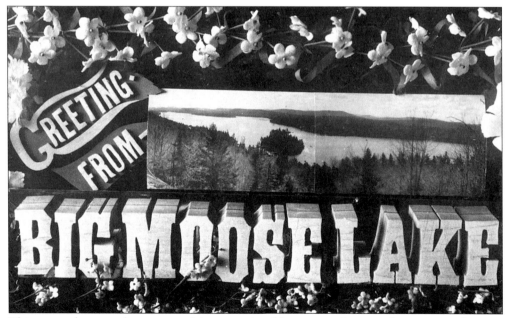

This unusual postcard was created by arranging blossoms and cutout letters around a rare panorama postcard.

INTRODUCTION

By a remarkable coincidence, the building of a railroad through the western Adirondacks in the early 1890s occurred at about the time that the U.S. Congress changed the postal laws and authorized the use of private mailing cards, or "postcards." Prior to this, all personal correspondence had to be in an envelope. As the railroad fueled the tremendous growth of Big Moose Lake, the exploding use of the newly authorized postcards conveniently documented that growth. Postcard publishers periodically took new pictures of camps and hotels, thereby recording the continuing expansion and change. The new postcards were a novelty to most people. Some sent postcards only because they knew the recipient collected cards. Others bought postcards to keep as souvenirs rather than to mail. From 1905 to 1935, the years of the postcard's greatest popularity, as many as a billion cards were mailed annually—more than ten for every man, woman, and child in the country.[1] The collecting of postcards helped to preserve the history of the area represented. Most of the postcards in this book are from the peak years mentioned.

Many of the cards depict hotels, boathouses, and camps that no longer exist. Indeed, it is difficult, and in some cases impossible, to find traces of what were substantial structures. Yet, some of the very oldest camps still exist, some are still in the original families, and some have been exquisitely restored and maintained—all of which greatly helped the compiling of this pictorial history and accompanying captions.

The earliest visitors to Big Moose Lake were led in overland by guides for spring fishing and fall hunting. With the arrival of the railroad, travel to Big Moose was greatly simplified and before long, hotels were built. The camps that had originally catered to guides and their parties adapted to serve families, often for the entire summer. Over the years, some hotels broadened their appeal by adding such amenities as tennis courts, cocktail lounges, theaters, stores, formal gardens, or barbershops, while others maintained their original rustic character and offered little more than a canoe rental and a hiking map. At one time, there were seven resorts on the lake but by 1974, Roy Higby reported that there were only four.[2] Since that writing Roy Higby's own Higby Club has ceased operations, as well.

1. Bogdan, Robert, "The People's Photographers," *Adirondack Life* Vol. XXX No. 6, (September/October 1999), pp. 56-61.
2. Higby, Roy C. *A Man From the Past*. Big Moose, NY: Big Moose Press, 1974.

IN THE GREAT NORTH WOODS

FILLED with shady nooks, cool lakes, charming retreats, sparkling brooks; with fish and game; the bracing air charged with the delightful odors of the balsam and the fir; pure cold water everywhere, free from contamination; the Adirondack Mountain region offers facilities for summer residences for the millionaire, the clerk, the banker or the tired worker, the professor or the student, that can scarcely be duplicated anywhere else in the world.

Within a few hours' ride by the fast trains of the

dwell more than ten millions of people, and almost within sound of the whistles of the great ocean liners from the British Isles and Europe are the pathless woods of this wonderful region.

Take a trip back in time—70 to 90 years—when vacationers arrived by steam locomotive, were carried to the lake by carriage, and then boarded the steamboat that took them to their destination on the lake. Join us on a visual tour of Big Moose Lake's heritage as we celebrate its history. We hope that our re-creation of the original trip from the railroad station to the landing and the steamboat trip around the lake will be enjoyed by residents and visitors, young and old, for years to come.

—Frank Carey
—Bill Scheffler

One

BIG MOOSE STATION, AINSWORTH'S, AND THE ROAD TO THE LAKE

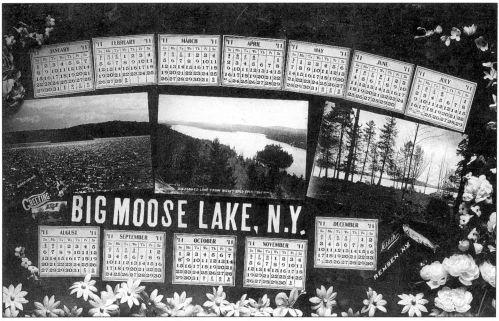

This unusual postcard was made by photographing three postcards arranged with flowers and calendar pages from 1911.

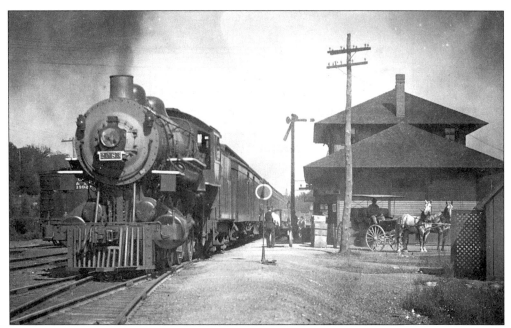

The railroads were the lifeline of the Adirondacks in the early years; the New York Central's Adirondack Division served the western Adirondacks. This line was built in the 1890s and the Big Moose station was one of the earliest on the line. The railroad passed within sight of Big Moose Lake and the station was about two miles from it.

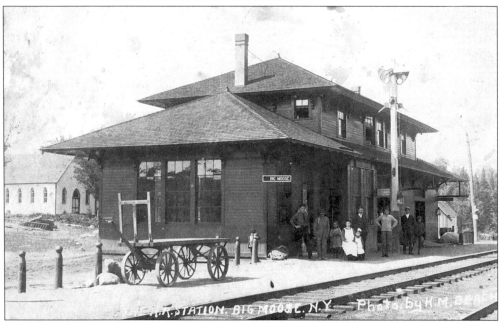

A small village evolved in the area of the station. This community was referred to as Big Moose Station to differentiate it from Big Moose Lake. This small village never had more than a few dozen homes and small businesses. By the 1920s, the peak of rail service in the area, there were ten passenger trains a day serving Big Moose. There was also regular freight service throughout the life of the railroad. The New York Central ended passenger service in 1966.

A carriage road was cut through the wilderness from the railroad station to the lakefront, and the Big Moose Transportation Company was founded to transport travelers and freight to the hotels and camps on the lake. On this ticket from 1913, the preprinted names of the stops can be seen. The list starts with Big Moose Station, followed by the landing at the point where the road ended at the lakefront and where continuing passengers boarded a steamboat. Then follow the names of the hotels and camps served by the steamboat. The punching on this ticket shows that it was used for a return trip from the lake to the station. Readers familiar with the earliest families of Big Moose Lake will recognize several misspellings on the ticket: J.A. William's should be A.J. William's, Shropsline's should be Shropshire's, and Ruter's should be Retter's.

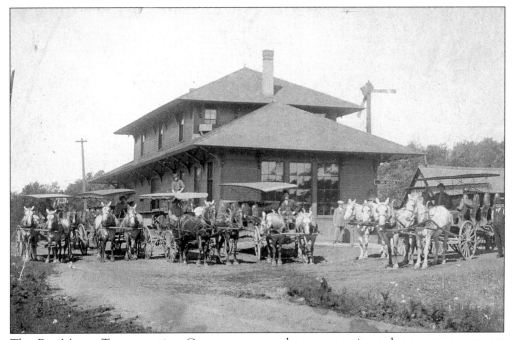

The Big Moose Transportation Company operated teams, as pictured, to carry passengers from the station to the lake. When roads were later built to serve the area, some of the hotels began to operate their own carriages for the convenience of their guests. (Picture courtesy of Wanda Martin.)

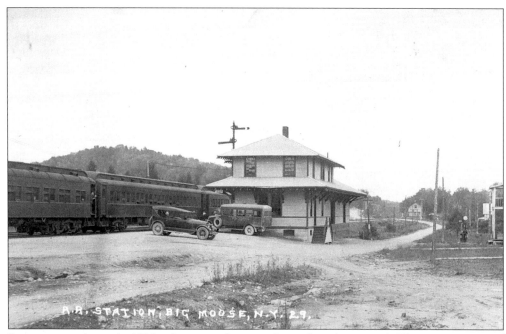

Sometime in the early 1920s, the original station burned to the ground. This new station, of similar style, was erected adjacent to the original site. By that time, the Big Moose Transportation Company had replaced its teams with the bus seen in this picture. Today, the station is privately owned and contains a restaurant.

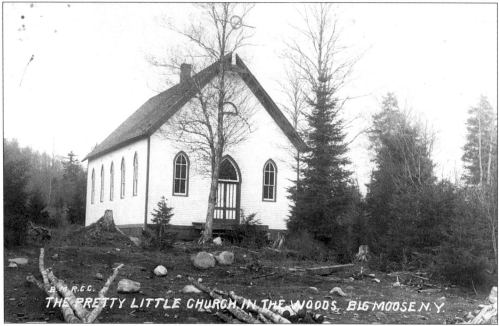

This small Catholic church was built about the same time as the original station and was located just west of it. The church served Big Moose Lake residents and vacationers, as well as workers at the logging camps that periodically operated nearby. The church was demolished in the late 1990s by church authorities.

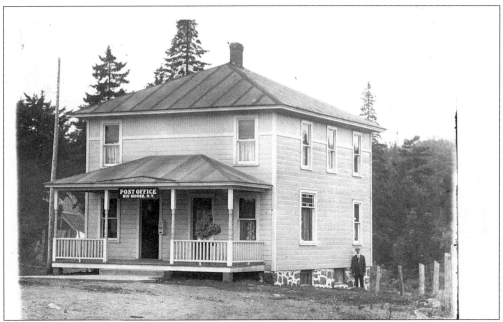

Post offices were, of course, an important element in any community. At Big Moose, the post office was usually operated out of the home of the then-current postmaster and was always located in the Big Moose Station area rather than at the lake. This building, known as the Denio house after an early tenant, still stands at the end of the station parking lot and is still a private home.

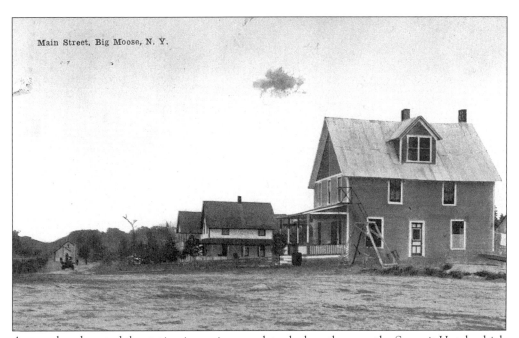

As travelers departed the station in carriages, or later by bus, they saw the Summit Hotel, which stood across the street from the station and which appears in the foreground of this 1916 postcard. The building has been gone for decades.

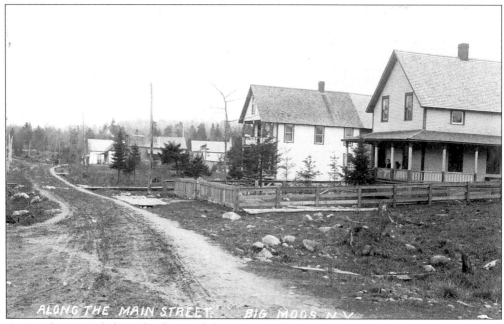

As travelers passed along the dirt road that was Main Street in Big Moose Station, they passed the few residences, boardinghouses, and businesses that comprised the village.

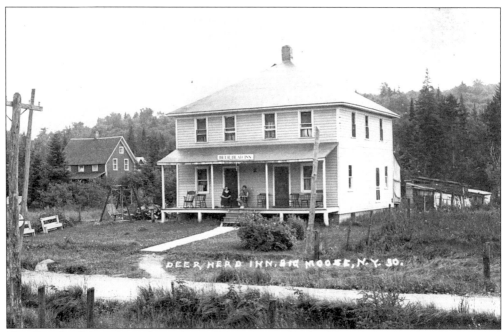

The Deerhead Inn dates from the earliest times. This building is still standing but has a considerably enlarged porch, which wraps around both sides of the building and which was added sometime after the 1920s, when this picture is believed to have been taken.

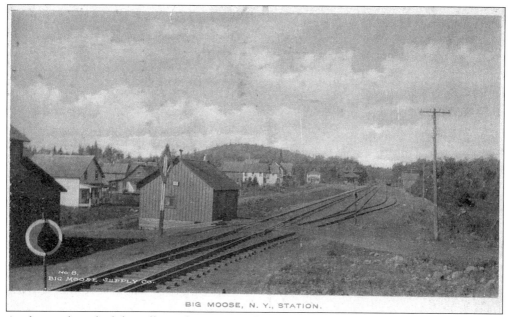

BIG MOOSE, N. Y., STATION.

At the south end of the village, the main road crosses the tracks and heads toward the lake. Travelers who looked back saw the view that is pictured on this 1913 postcard. The small structure in the foreground is the handcar house, where the railroad maintenance crew kept the handcar. To the left is the Marleau family store, which was built in 1907 and which still stands. In the distance is the Denio house, with the station to the right.

BIRDS EYE VIEW, BIG MOOSE N.Y. Photo. by H.M.Beach.

This 1920 postcard view, in the same general direction as the previous image, shows that the handcar house has been removed. The house obstructed vehicle drivers' vision at the crossing, where a truck driver had been killed by a train that he didn't see. The structure was relocated to a spot near the Twitchell Lake road, where it was enlarged and operated as a store. The store closed many years ago, but the building is still standing.

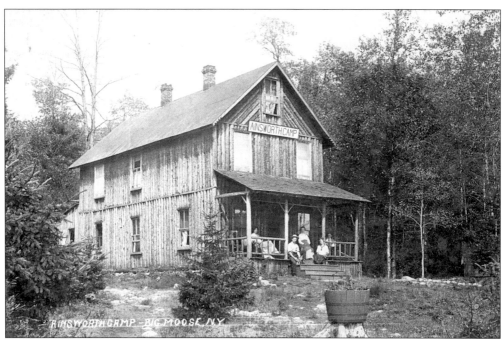

As travelers continued down the road toward the lake, they passed the Ainsworth Camp. This scene shows the original Ainsworth Camp building; the man on the porch step is Dan Ainsworth Jr., son of the camp founder.

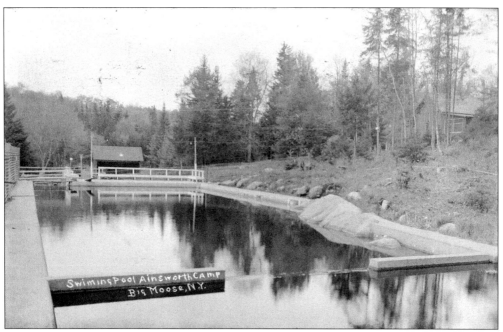

As the area grew, so did Ainsworth's. This swimming pool was added and for many years, it was the only one for miles around. It was created by damming a small brook. It has not been used in years but is still clearly visible along the road.

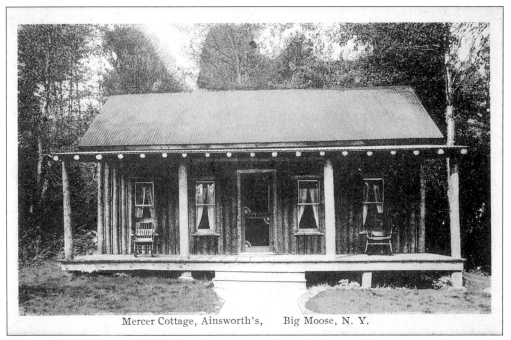

Built in 1906, Ainsworth's Mercer Cottage was located close to the road and next to the swimming pool. Seen here in a 1919 postcard, it was later enlarged to the rear. Today, it still stands and is in reasonably good condition but is unused.

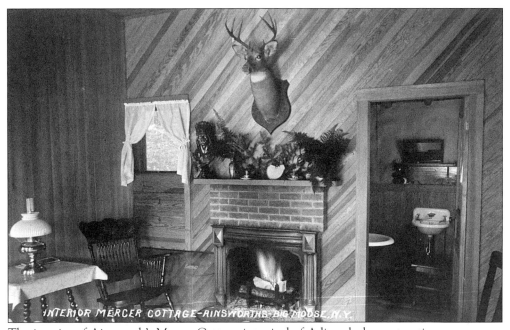

The interior of Ainsworth's Mercer Cottage is typical of Adirondack construction.

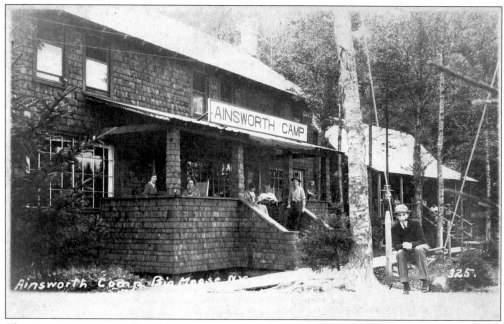

This newer main camp building at Ainsworth's was built adjacent to the original structure. Brown Cottage was built beyond it, so that most of the Ainsworth buildings were in a line close to the road.

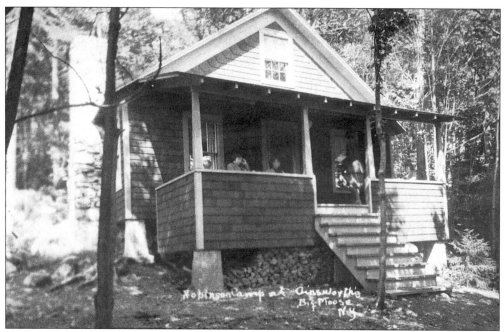

Ainsworth's Robinson Cottage was to the right of Brown Cottage and higher up the mountain, slightly away from the road. Today, the house is used as a private residence. Ainsworth's ceased operation decades ago, and many of the camp's other buildings are now gone.

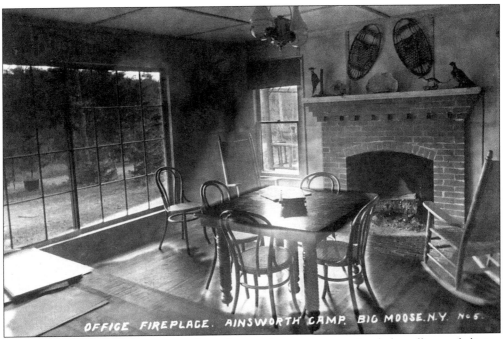

Ainsworth's main building, pictured on the previous page, contained the office and dining room for the camp. This postcard was mailed on August 26, 1915, and the message read: "A very nice place. There are about twenty-two people here. They have had lots of rain here. Maude."

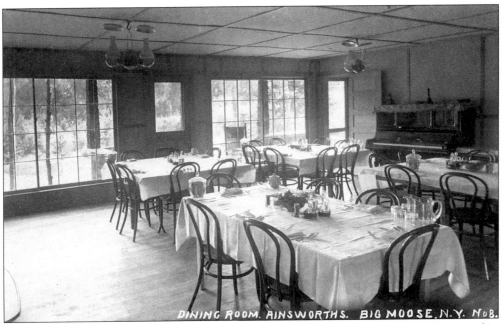

Meals in the Adirondacks were frequent and hearty. The dining rooms, as at Ainsworth's, sought to be comfortable, modern, and simple.

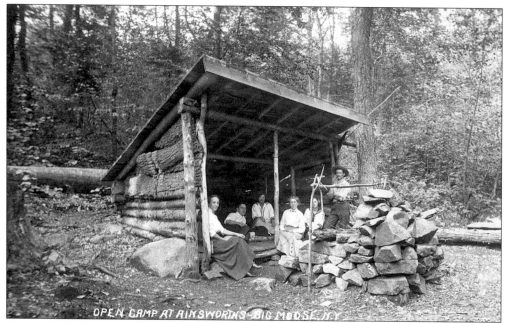
No Adirondack camp was complete without a lean-to, or open camp. Ainsworth's had theirs.

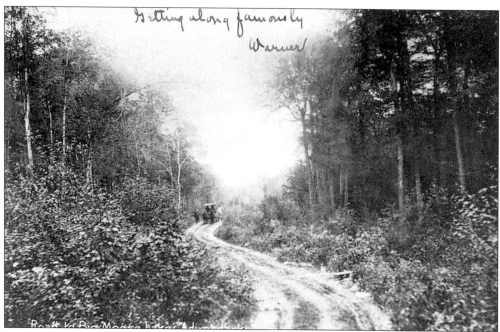
Leaving Ainsworth's the road to the lake, as seen in this 1906 postcard, is quite narrow and crudely built. Passengers must have had a slow, bumpy, and dirty trip.

Two

THE GLENNMORE AND THE BIG MOOSE SUPPLY COMPANY

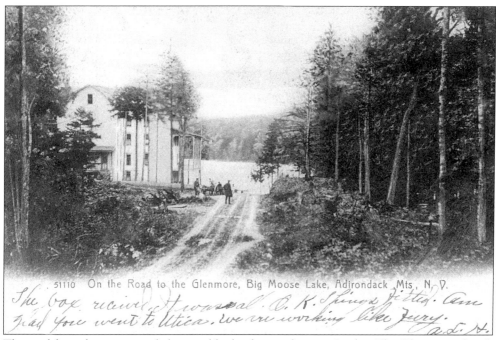

The road from the station ended at a public landing at the water's edge. The Glennmore hotel, built soon thereafter at this point, was named after a very early pioneer by the name of Glenn. Over the years, the hotel name was spelled both as Glennmore and Glenmore.

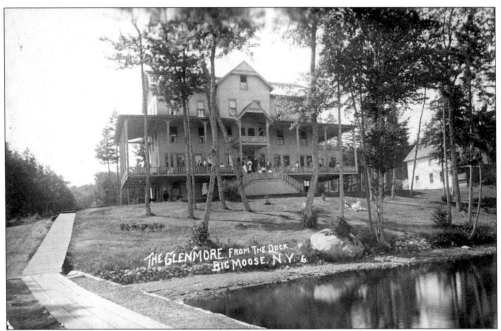

This postcard dates to the very earliest years of the Glennmore and shows it as it was originally built. The first of several cottages is seen in the right of the picture. This card is postmarked 1908 and was canceled by a post office operated aboard a steamboat on the nearby Fulton chain of lakes.

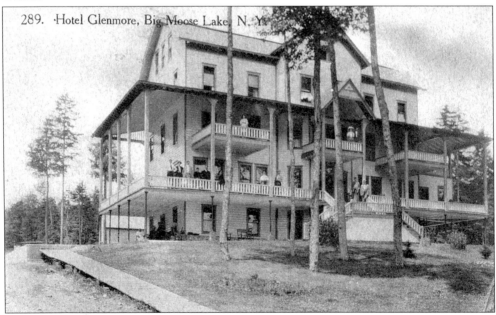

The Glennmore went through a continuing evolution during its years in operation. This picture was taken only a few years after the one above; yet, it shows that new balconies had already been built above the main porch. The Glennmore's location at the end of the lake on a site that rises up from the water afforded a fine view of the lake and no doubt contributed to the expansion in general and these new balconies in particular.

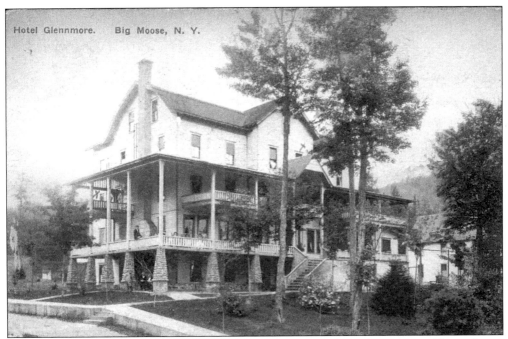

Improvements to the Glennmore continued. In this postcard, used in 1921, additional new balconies, a masonry chimney originating from the fireplace that was added to the sitting room, and new stone piers supporting the main porch can be seen. The wooden plank walkways have been replaced with concrete sidewalks and steps.

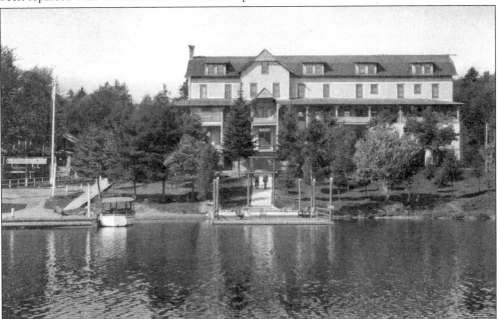

This card was not mailed but is probably from the 1930s. It shows further change. A substantial addition has now been built on the east end, dormers have been raised in the roof, and the Glennmore now has its own dock at the waterfront to the right of the landing and public dock. The hotel maintained this configuration until it burned in 1950.

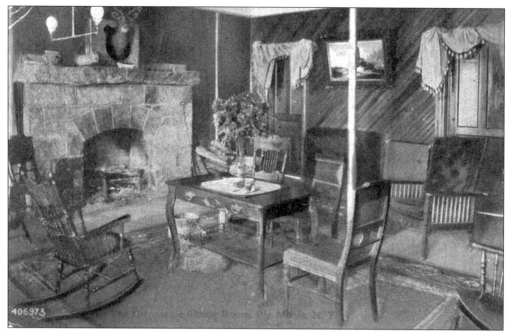

The Glennmore living room was quite formal, with oriental carpets, a cut stone fireplace, and a conspicuous absence of rustic décor save for the mounted deer head over the fireplace. Furnishings appear to be period Victorian; gas lighting is visible at the ceiling.

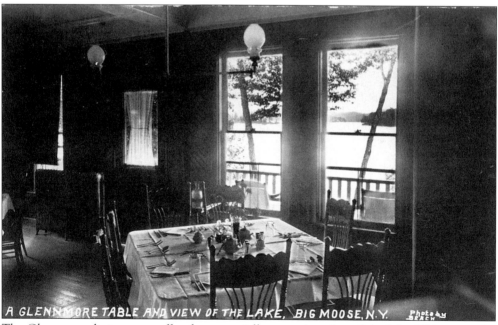

The Glennmore dining room offered an especially attractive view of the lake. This room also had gas lighting; the radiator to the left of the door suggests that the hotel had steam heat, as well. Steam heat and gas lighting were uncommon in the Adirondack wilderness.

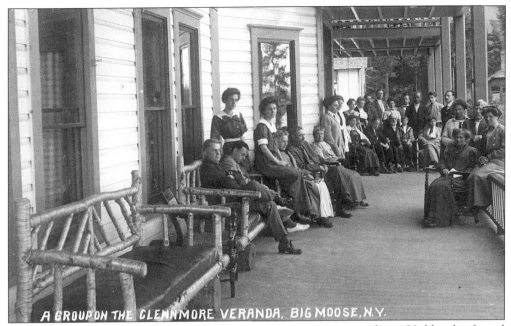

Porches and verandahs were popular places to congregate, as seen here. Unlike the formal interior rooms, the verandahs were furnished with rustic furniture, likely made nearby from local materials.

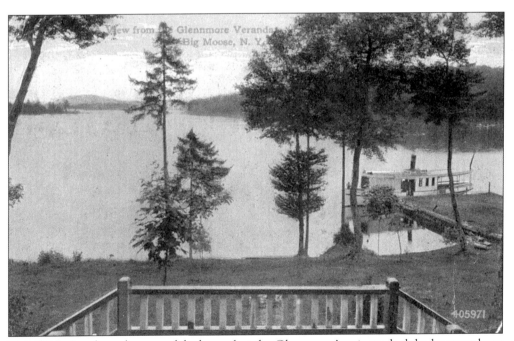

This 1917 view from the verandah shows that the Glennmore's private dock had not yet been built. Visible to the right are the steamboat of the Big Moose Transportation Company, its landing, and the public dock where it was based.

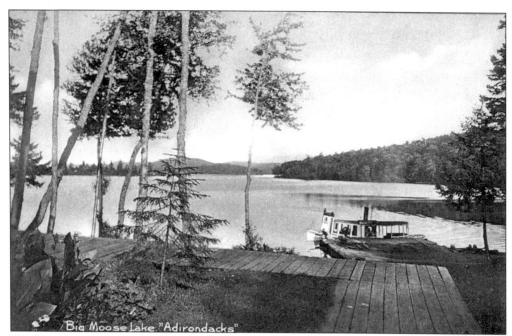

The first Big Moose Transportation Company steamboat was the *Zilpha*, pictured here. It was fairly small and had a wheelhouse in the bow, from which it was operated. As tourism increased, a larger boat became necessary and this smaller boat was retired from service *c.* 1907.

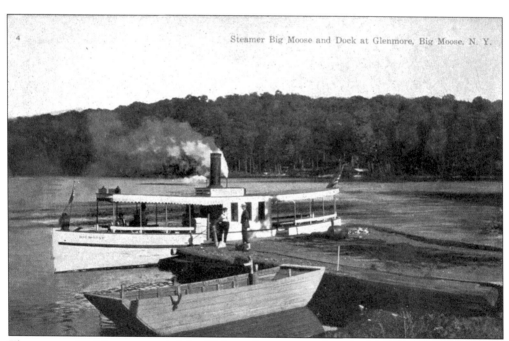

The steamer *Big Moose* succeeded the *Zilpha* and was operated on the lake for many years. It was the boat in use when the ticket shown on page 11 was used. This boat stopped at all hotels and at many camps, as noted on the ticket.

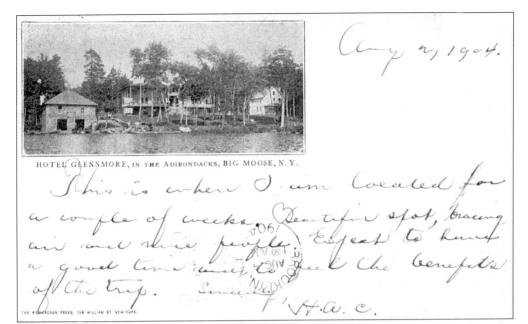

The picture on this 1904 card shows the original Glennmore boathouse, the public landing, the Glennmore hotel, and the first Glennmore cottage, known as White Cottage. Today, all of these structures are gone. This card was mailed to Brooklyn, New York, and the message states: "This is where I am located for a couple of weeks. Beautiful spot, bracing air and nice people. Expect to have a good time and to feel the benefits of the trip. Sincerely. H.A.C."

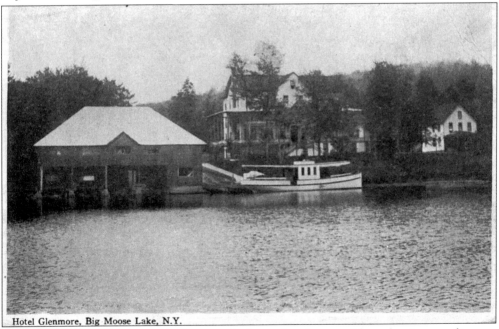

Before long, the Glennmore built a much larger boathouse with a dancing pavilion on the second floor. The boathouse still stands and is now privately owned; its second floor has been converted into apartments. In this image, the steamboat *Big Moose* is tied up at the landing.

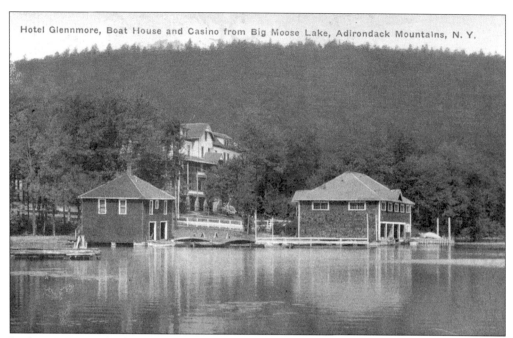

In this 1927 view, both Glennmore boathouses are visible. The first is on the left; it was moved to make way for the newer one.

Many Adirondack hotels expanded by building cottages on the hotel grounds when further enlargement of the hotel was impractical or impossible. The Glennmore had seven such cottages along the waterfront, which were reached via this wooden walkway.

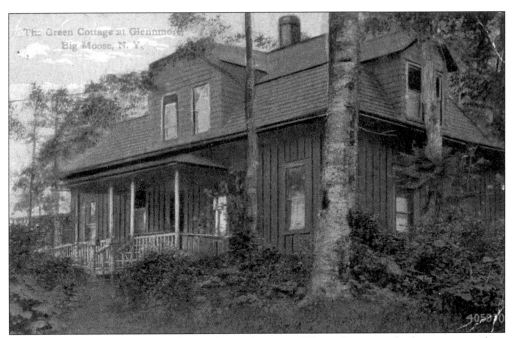

Green Cottage, which still stands, was located next to White Cottage, which was pictured on page 27. White Cottage was destroyed in the 1950 hotel fire, but all the other Glennmore cottages survived. Today those cottages are all privately owned.

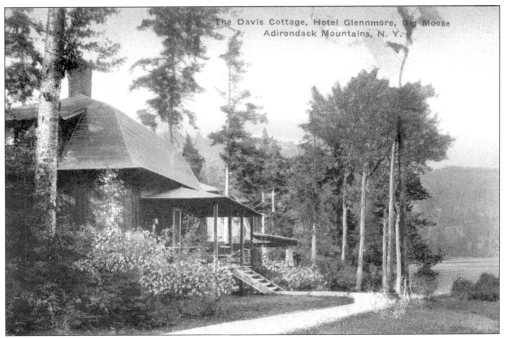

Davis Cottage was located to the east of Green Cottage.

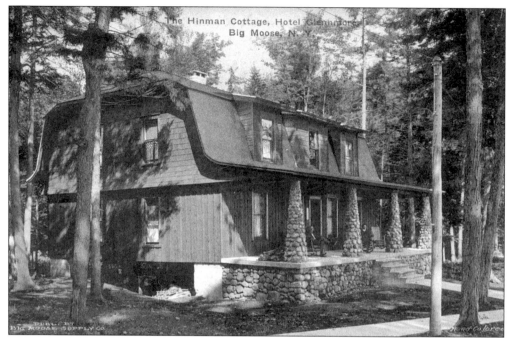

Hinman Cottage was the last cottage at the eastern end of the boardwalk. This postcard was mailed to Rahway, New Jersey, in 1921. It bore a long message, which ended with "We are in this cottage—'tis very nice."

The Glennmore had an open camp in the woods, which was a popular spot with guests.

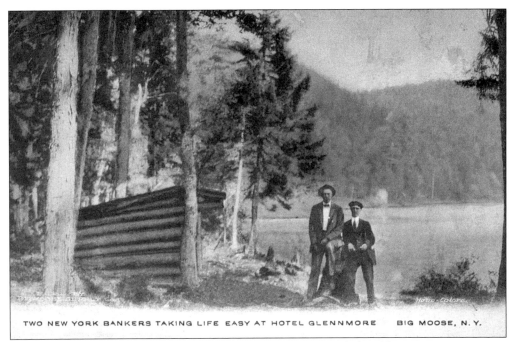

TWO NEW YORK BANKERS TAKING LIFE EASY AT HOTEL GLENNMORE BIG MOOSE, N.Y.

This postcard appears to be older than the previous one of the Glennmore open camp. Although the camp structure is different, the location is believed to be the same. At some point the older camp was probably replaced by the newer one.

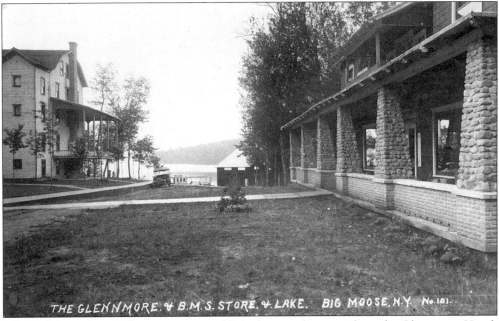

THE GLENNMORE & B.M.S. STORE & LAKE. BIG MOOSE, N.Y. No. 101.

The Big Moose Supply Company was established across the street from the Glennmore Hotel; the company's store is shown here on the right. The store was a truly general store, supplying everything from food to hiking boots to hardware.

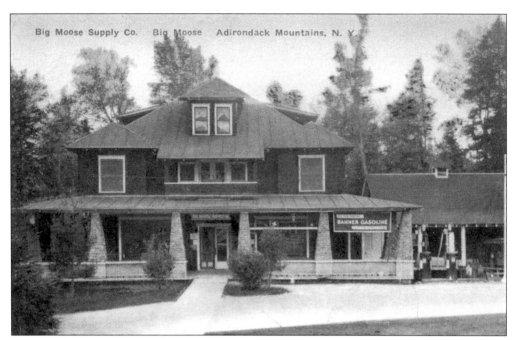

A later view of the Big Moose Supply Company store shows that it had begun selling gasoline and had added outbuilding to the side. Following the burning of the Glennmore in 1950, the store was converted to a restaurant and given the Glennmore name. Today, it is still in business.

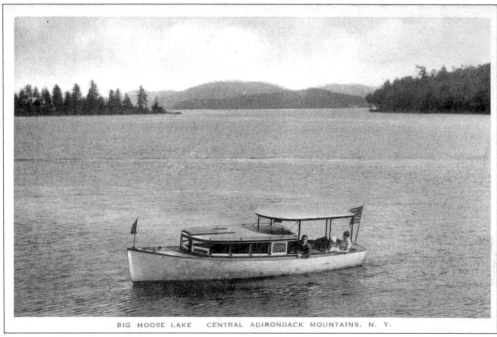

The Big Moose Supply Company also operated the "pickle boat." The term pickle boat was a generic name given to any Adirondack boat that served as a floating store and visited camps around the lake. This pickle boat operated into the 1930s.

Three
THE CHAPEL AND BURDICK'S

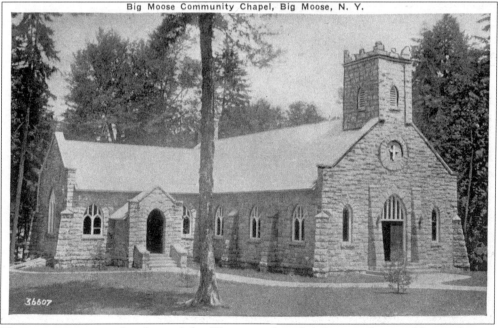

Those passengers traveling beyond the Glennmore boarded the steamboat and began the trip around the lake. The steamboat stopped at hotels and camps to pick up and discharge passengers. After leaving the landing at the Glennmore, the steamboat crossed West Bay, passing the location where this chapel was later built. Much has been written about the Big Moose Community Chapel, and it has been a recognized historical landmark for years. It is still in regular use today and has been well maintained over the years by a dedicated congregation.

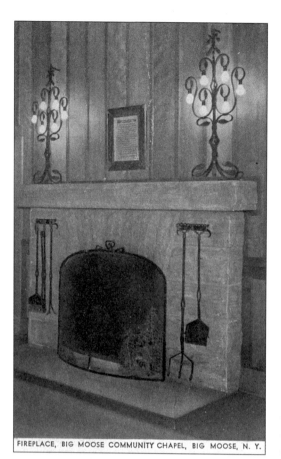

FIREPLACE, BIG MOOSE COMMUNITY CHAPEL, BIG MOOSE, N. Y.

Chapel architect and builder Earl Covey was famous for his fireplaces; the chapel fireplace is a masterpiece.

The chapel has been a popular subject of postcards from the time it was dedicated on August 2, 1931.

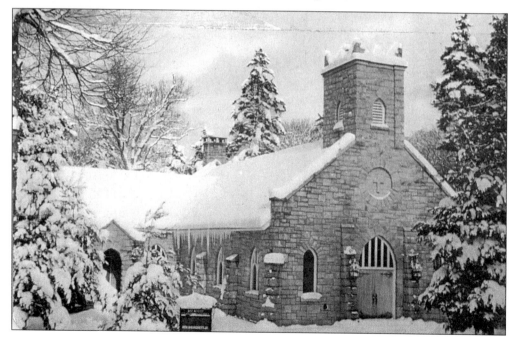

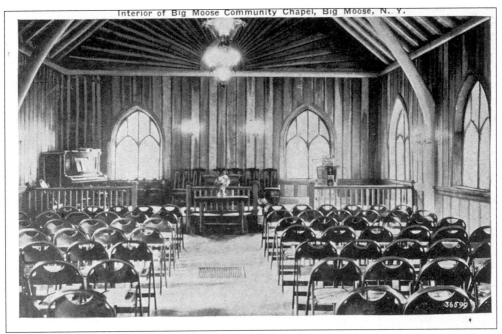

When it first opened, the chapel did not have pews but rather used the folding chairs seen here.

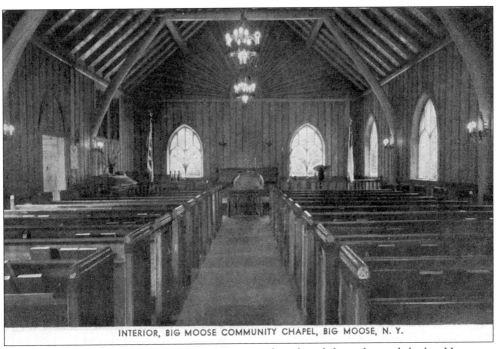

Since the adding of pews in the early years, the chapel has changed little. However, the enormous natural burl that served as a lectern, visible at the far end of the chapel, has been replaced.

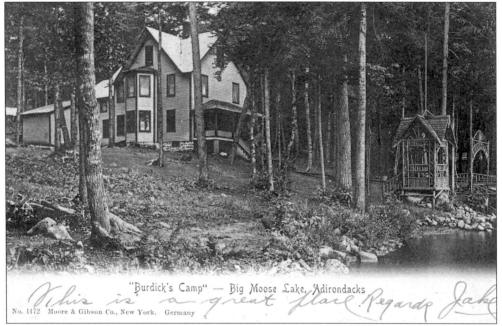

The first steamboat stop after leaving the public landing at the Glennmore was Burdick's Camp, built in 1902. This 1908 postcard shows Burdick's Camp as it was originally built. It was traditional late Victorian architecture, which over the years evolved and changed—as did so many other Adirondack hotels and camps.

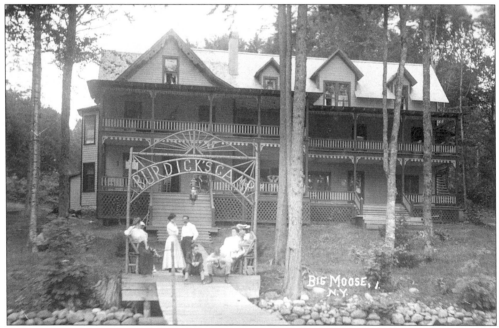

Early changes to Burdick's included a substantial addition to the western end and the addition of generous porches on the first and second floors. Porches and eaves acquired intricate gingerbread trim. The rustic sign is characteristic of Adirondack camps and is a reminder that at the beginning, Big Moose camps were approached from the water rather than from the road.

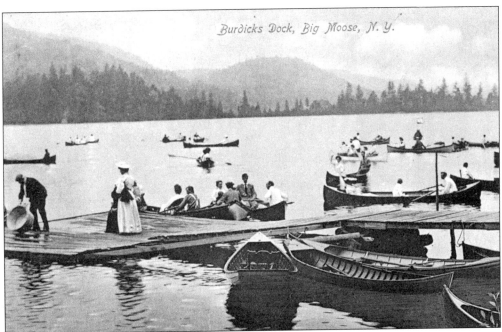

This view shows a remarkable assembling of classic Adirondack guide boats. Boating was certainly one of the most popular pastimes at the lake, and these guests appear to be comfortable boating in jackets, ties, hats, and street-length dresses. The question is what is the man on the dock about to do with the wooden tub he is handling?

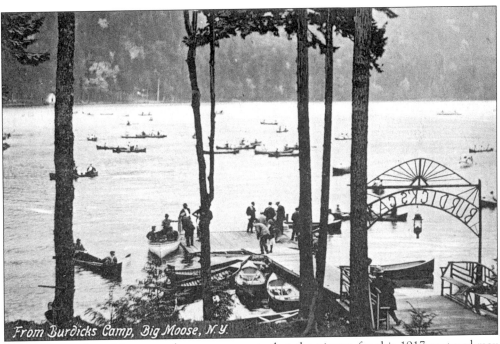

The sheer number of boats on the water suggests that the picture for this 1917 postcard may have been taken on the annual Regatta Day.

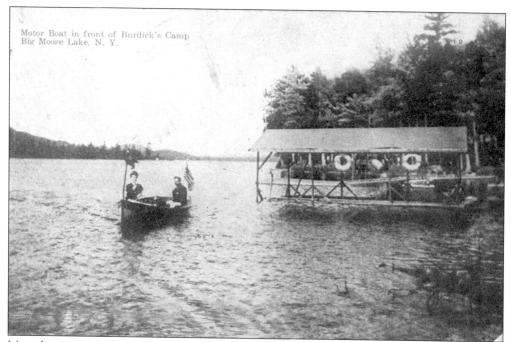

Motorboats were rare in 1910, the year that this card was sent. The message reads, "Uncle Charles, well I have broke the record by killing a big buck on the first of hunting—he was a dandy with a big head. Come up and we will have our annual hunt again—the deer are plenty [sic]. G.A. Burdick."

Burdick's open camp appears to have been located on the spot where Dunn's Boat Livery was later built.

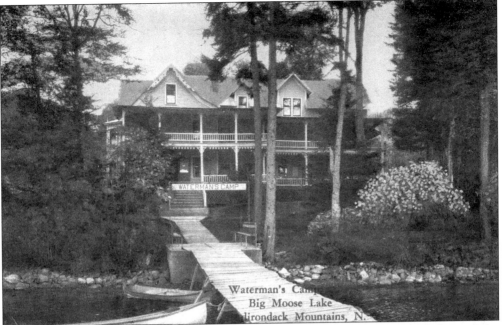

By the early 1930s, Leonard Waterman had acquired Burdick's Camp and had changed the name to Waterman's Camp. In this view, postmarked 1934, very little save the name sign seems to have changed since Burdick added the porches and trim.

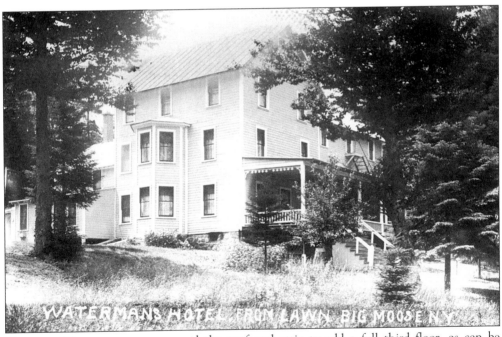

However, Waterman soon removed the roof and attic to add a full third floor, as can be seen in this postcard dated 1936. A new roof of rather different design was then added to complete the expansion. In this form, the building began to resemble the Big Moose Inn that it eventually became.

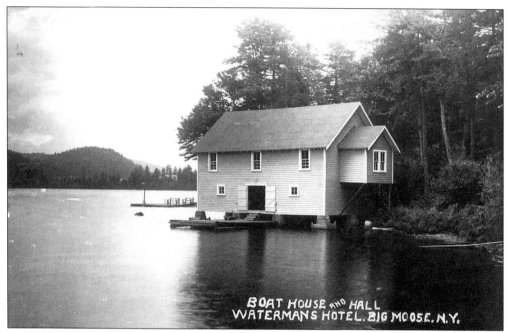

Burdick's never had a boathouse. Waterman remedied this by erecting this large boathouse at the eastern end of his property. The boathouse no longer stands.

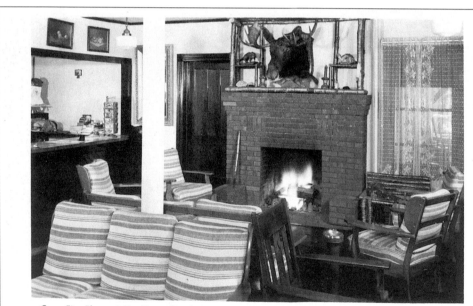

Waterman's passed through several additional owners after the 1930s; at one time it operated as the Big Moose Hotel, before becoming the Big Moose Inn. Visitors to the Big Moose Inn today will recognize that the lobby fireplace and office counter have not changed much in more than six decades.

Lake Side Cottages Big Moose Hotel, Big Moose Lake, N. Y.

Two cottages were built to the west of the hotel's main camp to increase capacity. These cottages still stand; they are privately owned and have undergone extensive modification.

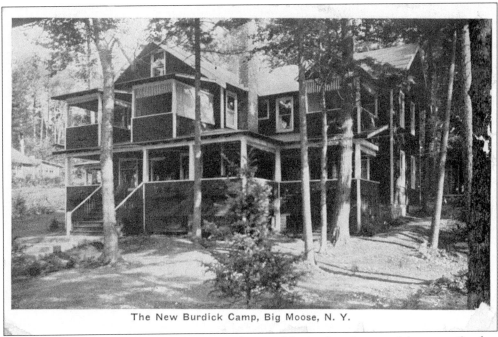

The New Burdick Camp, Big Moose, N. Y.

When Burdick sold to Waterman, he retained some of the land to the east of the camp. On that land he soon built the New Burdick Camp. This building still stands today but no longer operates as a hotel. Dunn's Boat Livery was built between the building and the water's edge, and this camp, which had a small store in the 1960s, is now empty.

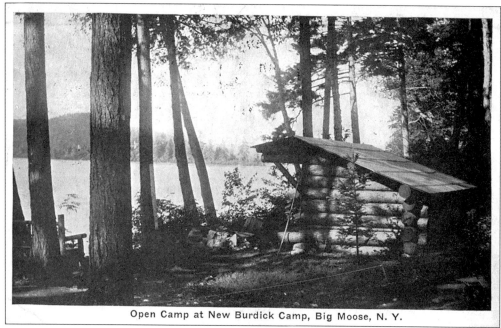

Open Camp at New Burdick Camp, Big Moose, N. Y.

The New Burdick Camp had an open camp for the enjoyment of its guests.

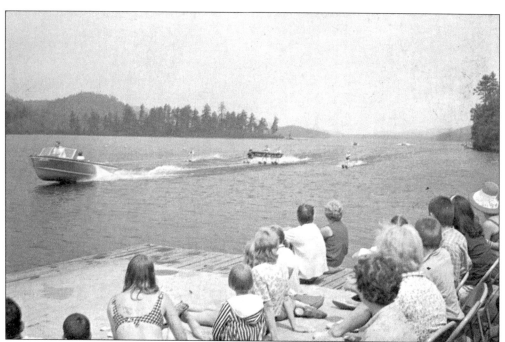

In this postcard view, the dock at Dunn's is filled with spectators watching a water-skiing demonstration by five skiers. These shows were conducted periodically in the 1960s by local young people.

Four
Lake View Lodge

One of the Rustic Cottages, West of the Lodge

As the steamer *Big Moose* continued along the south shore, the next stop was William's Lake View Lodge. While the hotel was built in the style of the day with large verandahs, the cottages were rustic in style and built with locally obtained bark-covered logs, as seen on the cover of this Lake View Lodge brochure.

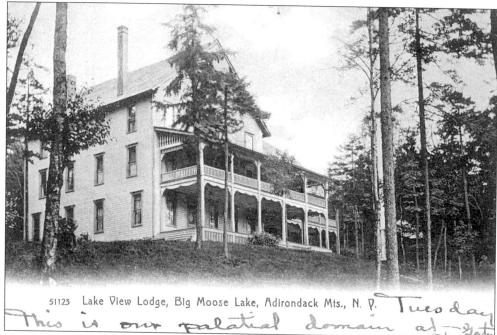

This 1907 postcard of Lake View Lodge shows the lodge as it was built less than ten years earlier. At the time this card was published, postal law required that one side of the card contain only the address. For this reason, early postcard publishers left space on the front of the card so that a brief message could be written.

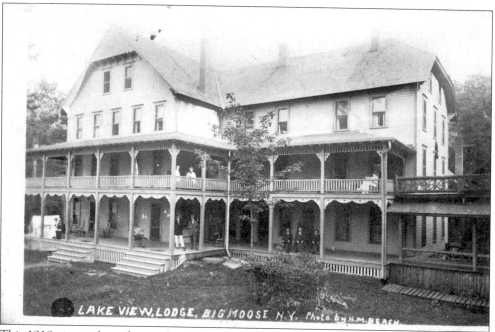

This 1918 view is from the northwestern side. The hotel had not changed significantly in the 11 years that had elapsed since the previous postcard was published.

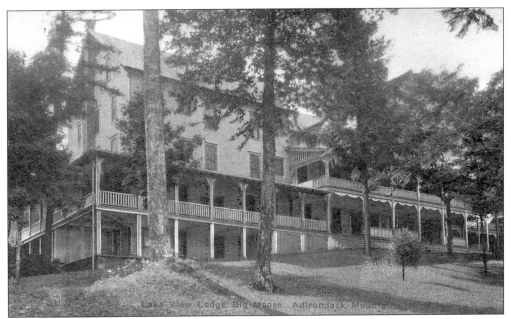

A substantial addition was eventually added to the eastern end of the original hotel, changing the roofline, as seen here. The older portion still has its original second-floor verandah, which helps identify where this new addition begins. Lake View Lodge ceased operation in the 1960s, at which time the building passed into private hands. Since then, a portion has been demolished and the remainder has been maintained as a private camp.

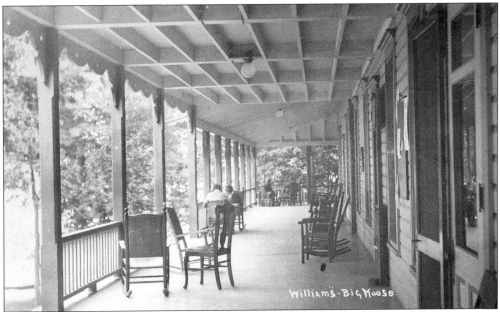

The popularity of verandahs no doubt increased in inclement weather, as indicated by the message on this postcard sent to Ridgewood, New Jersey, in 1954: "Have walked miles on this porch on rainy days. It's three times as long as it appears. Had a good summer in spite of rain and cold weather. Lots of friends and all of our children. That is happiness. Much love to you…"

45

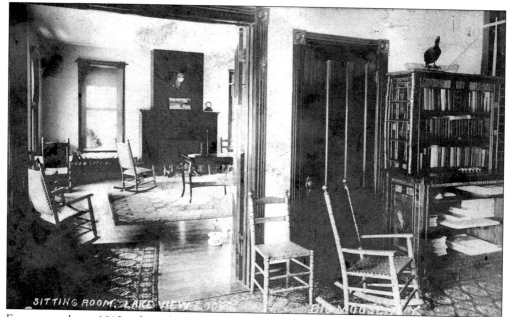

Even as early as 1912, when this postcard was sent, Lake View Lodge had a well-furnished sitting room.

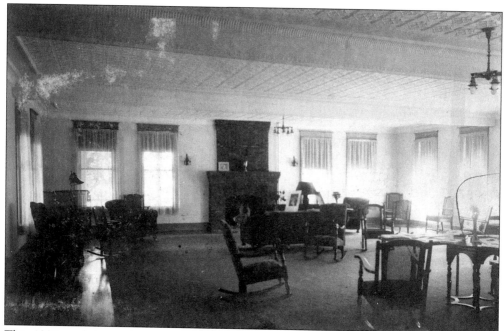

This 1924 card shows the appointments of the sitting room in greater detail. The intricate Victorian ceiling is clearly visible, as are the fine curtains hanging in the large windows on three sides of the sitting room. Ceiling lighting fixtures appear to be electric.

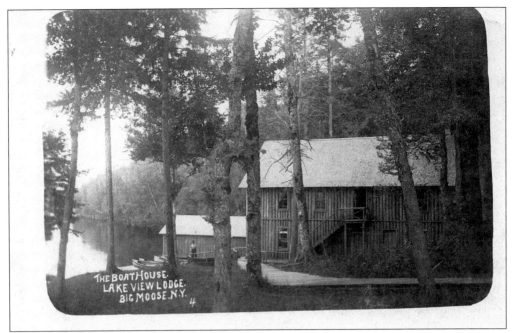

A substantial boathouse was built near the water's edge to house the many canoes and guide boats that Lake View guests required. Note that the roof is pitched on the sides and that a gable faces the lake. This later changed. The smaller boathouse, built over the slip that housed the Lake View launch, is visible to the left of the main boathouse.

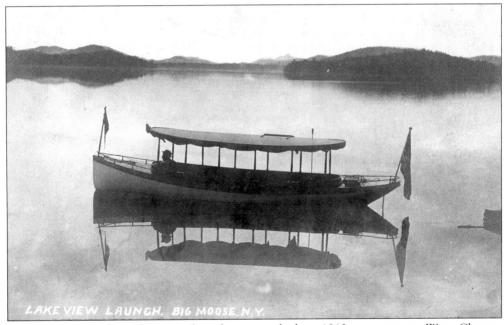

This postcard of the Lake View launch, postmarked in 1912, was sent to West Chester, Pennsylvania. The launch was used to transport hotel guests as needed.

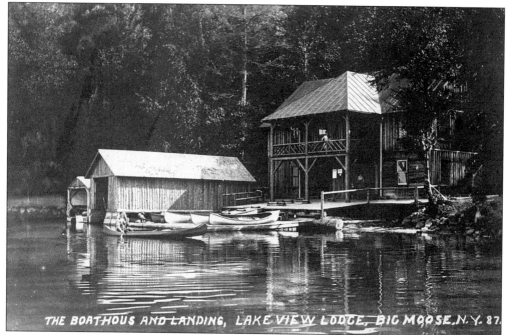

Sometime in the very early years, the boathouse was turned so that the longer side faced the water. This must have been an extremely difficult task, and why it was done is unknown. Careful examination of this view will show that the main roof behind the porch now slopes from front to rear and that the gabled ends are on either side. The large porch was likely added at the time the boathouse was turned. The boathouse was demolished in the 1980s to build a new camp in its place.

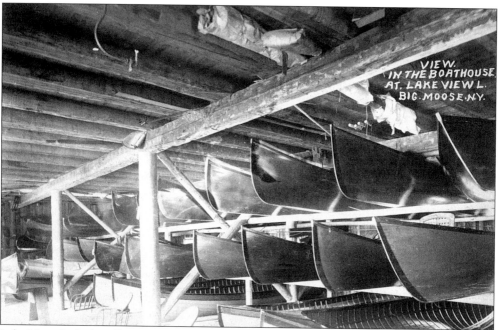

Lake View Lodge's collection of guide boats would be worth a fortune today.

Like the other hotels on the lake, Lake View Lodge expanded and grew by building many cottages along the lakeshore.

Also like the other hotels, a wooden path that followed the shoreline facilitated walking between the lodge and the cottages.

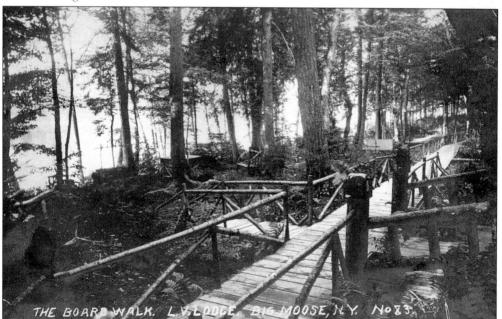

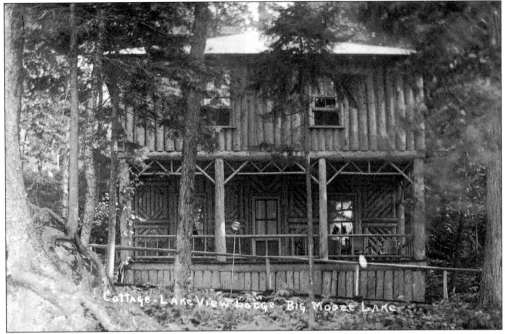

The card above shows one of the larger cottages, and the card below shows the so-called bungalow with its roll-down sides. The bungalow still exists, having been extensively modified as a private camp.

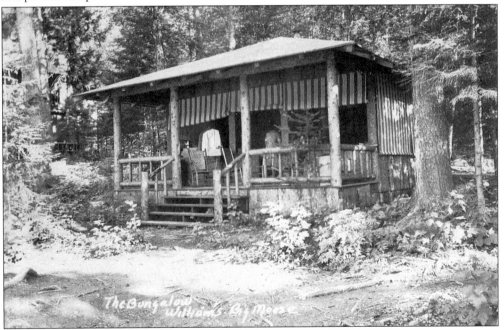

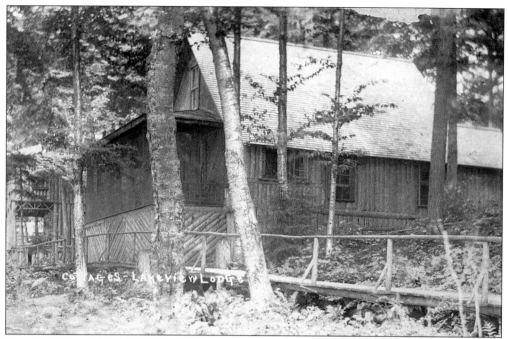

The message on this 1937 postcard states: "Just a card to let you know you are not forgotten. We are having a grand time as usual—weather fine and clear. Love to all."

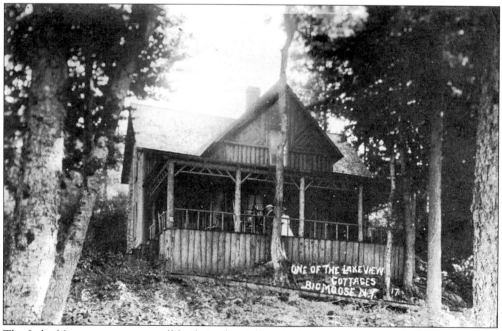

The Lake View cottages were all built in the Adirondack rustic style, using bark-covered logs.

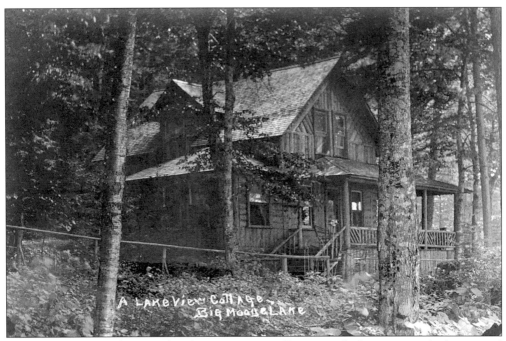

Cottages built to supplement a hotel's capacity typically consisted of one or more bedrooms and a sitting room. These cottages were especially popular with families who preferred to be together in a private cottage rather than spread throughout the main house.

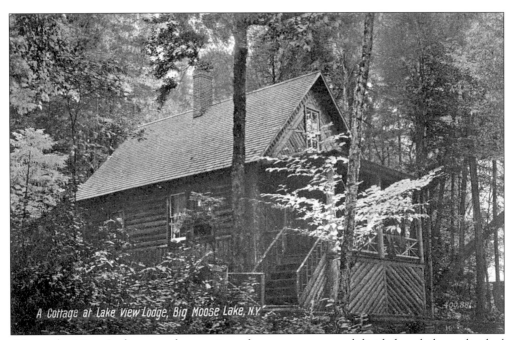

After Lake View Lodge ceased operation, the property was subdivided and the individual cottages were sold off and converted to private family camps.

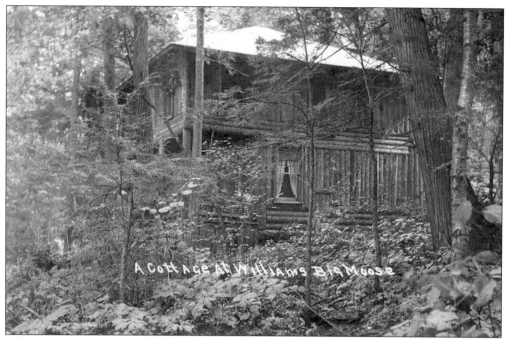

All of the Lake View Lodge cottages were on the waterfront. After they were sold off, the new owners developed their waterfronts and built docks. These properties now dot the West Bay shore.

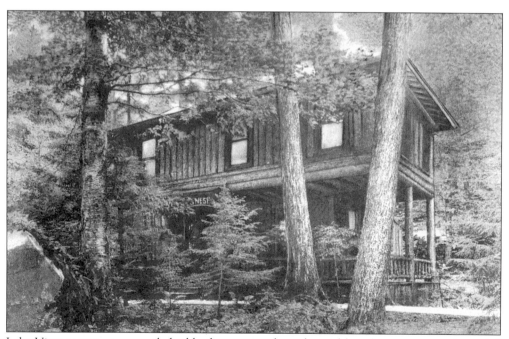

Lake View cottages apparently had both names and numbers, although many postcards carried neither. This particular card is, therefore, unusual in that it identifies this cottage as "Owls Nest (6th) cottage."

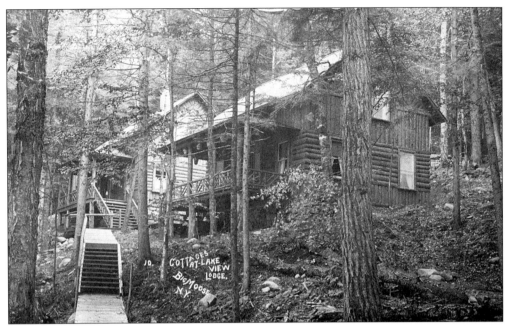

This view shows the cottages and the wooden walk that linked them together with the lodge.

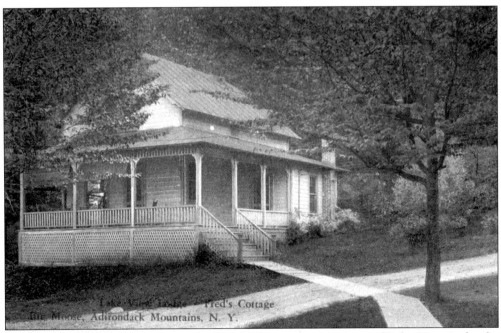

This card shows the private cottage of Fred Williams, the proprietor of Lake View Lodge for many years. This cottage was not along the lakefront boardwalk but was farther up the hill above the boathouse.

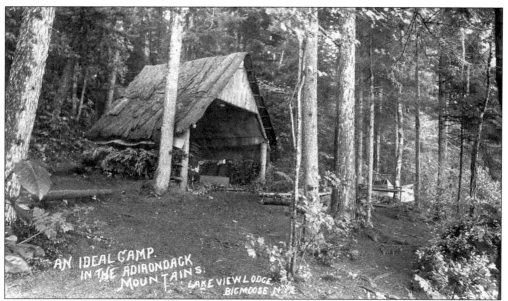

Lake View Lodge had several open camps. These two cards show two very different styles of open camp. In the upper picture, the open camp is of a somewhat unorthodox design and construction. It appears to be framed in timber and topped with an unusually and unnecessarily high peaked roof. Unlike the more traditional open camp, the siding appears to have been applied to the framing and does not appear to be supporting the roof. Open camps are the most primitive kind of permanent adirondack shelter, and there would be no advantage in this uncommon design. The aesthetics of a symmetrical design may have influenced the builder. The lower picture shows an open camp built in the traditional style. Logs are stacked horizontally, and a long rear-sloping roof drops to below standing-room height. A short front-sloping roof extends out beyond the camp opening. This traditional style is readily erected with a minimum of skills and tools.

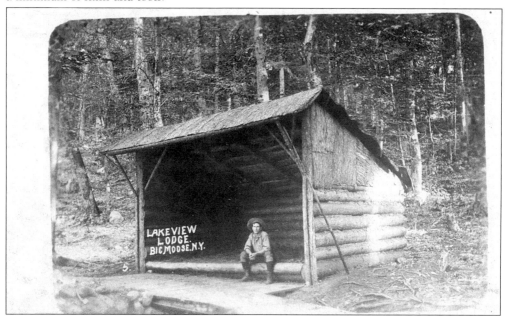

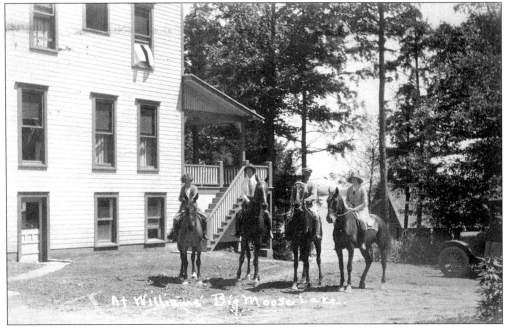
Lake View Lodge was well known for riding; its location gave guests easy access to a network of bridle trails.

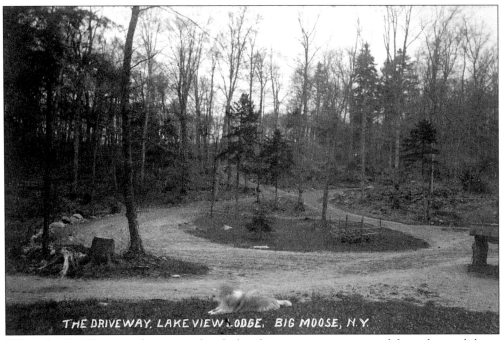
When the Big Moose road was completed, this driveway was constructed from the road down to the main camp, barns, and shops.

Postcard publishers often printed woodland or waterfront views to convey the beauty of a particular area. This card's view looks east toward South Bay. Lake View's boathouse roof is barely visible on the right.

This view looks in the opposite direction. Notice that the Glennmore boathouse roof is visible through the trees across West Bay.

In this westward view, the Glennmore boathouse is much more noticeable.

Postcard winter scenes of Big Moose are not nearly as common as summer scenes but are often as striking.

Five
Continuing Along the South Shore

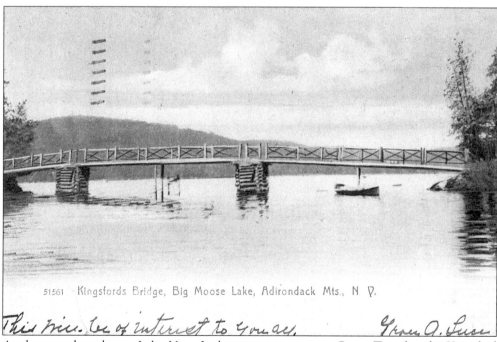

As the steamboat leaves Lake View Lodge, it soon comes to Camp Tojenka, the Kingsford family's camp.

Kingsford's camp enjoyed a prime location that afforded a fine view all the way to the eastern end of the lake. Its owners have meticulously maintained this camp over the years and today, it is a stunning example of Adirondack architecture and style.

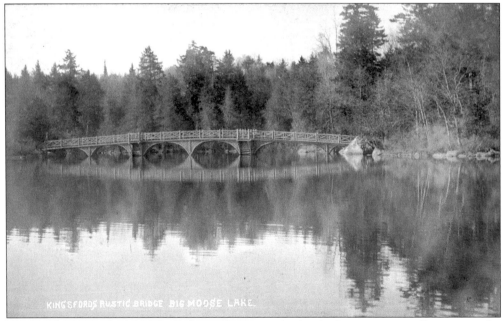

This card, postmarked in 1914, shows the rustic bridge built across a small cove on the Kingsford property. Few pictures of this bridge exist, and it is believed to have been short lived. It is not likely that such a delicate and exquisite structure could have survived many winters of Big Moose ice, which through natural expansion often destroyed unprotected docks and foundations.

From Kingsford's the steamboat proceeded a short distance to Dart's Landing and then crossed over to Crag Point, thus bypassing the lake's outlet and all of South Bay. Toward South Bay is Buzz Point, where Henry Milligan of Canton, Ohio, built this camp sometime before 1920.

Out on the tip of Buzz Point, Henry Milligan built a classic gazebo, which had a fine view into South Bay, as well as much of the lake. The Buzz Point property was later acquired by the owner of Covewood Lodge (see pp. 63–67), who incorporated it into that operation.

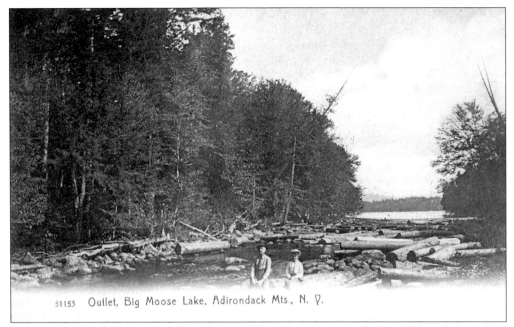

The outlet of Big Moose Lake is just beyond Buzz Point; this outlet begins the north branch of the Moose River. This postcard clearly shows sawed logs strewn among the rocks, evidence of the log drives known to have occurred from the lake into the Moose River during the spring runoffs, when the water is likely to have been high and fast.

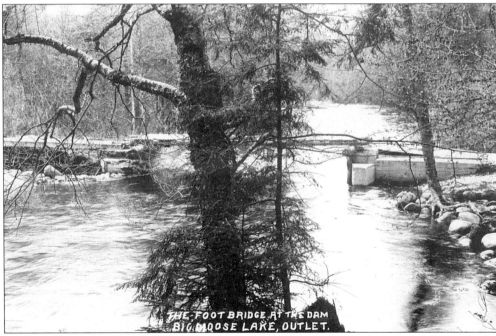

By 1916, when this card was postmarked, a small footbridge had been built across the outlet for the convenience of local camp owners and vacationers.

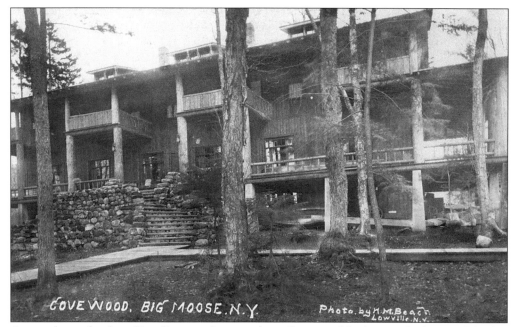

Across the outlet from Buzz Point is the site where Covewood Lodge was built, c. 1925. This two-story lodge was of rustic design and was built largely with local materials—trees and rocks—by Earl Covey, one of the premier builders of the area.

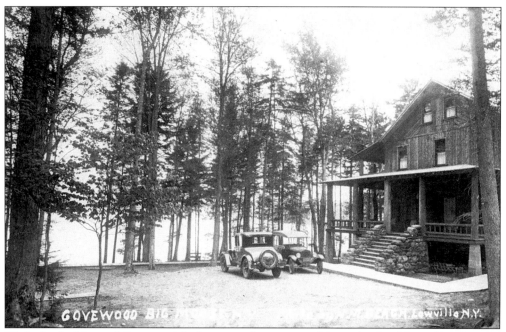

With the building of Covewood Lodge, a road was opened from the Big Moose Road to the outlet, where a bridge was constructed so that cars could drive right up to the door of the lodge. The steamboat had ceased operation before Covewood opened.

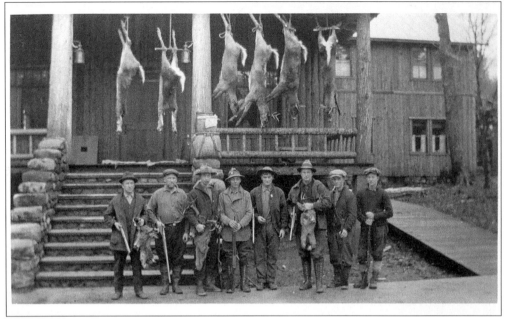

Most of the hotels and camps on the lake catered to sportsmen. In this early card from Covewood Lodge, a party of hunters, guided by Covewood builder and proprietor Earl Covey, left, display their deer from the west porch.

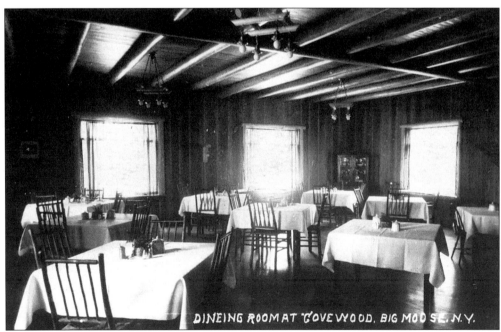

Covewood interiors have a rustic finish with peeled logs on the ceilings and board and batten walls. The view of the lake was and remains splendid.

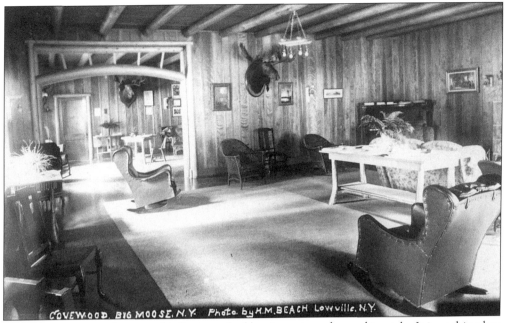

The sitting room at Covewood is finely crafted but is rustic and casual in style. It is nothing less than the exemplar of Big Moose design.

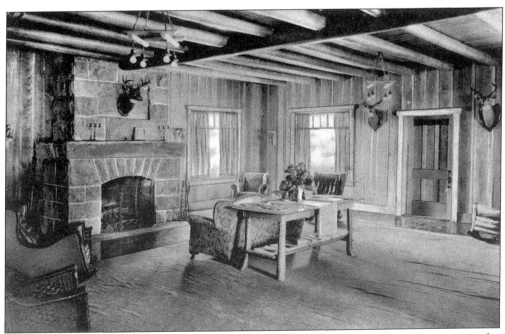

All Covewood interior surfaces are natural wood finish. This appearance was in contrast to the very formal styles of the Glennmore and Lake View Lodge.

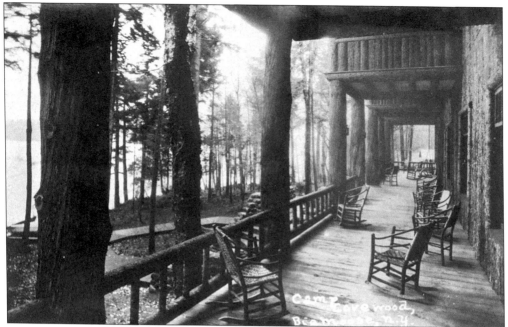

Covewood has a large verandah across its lakeside face. Small, private, second-story porches were provided for some of the bedrooms.

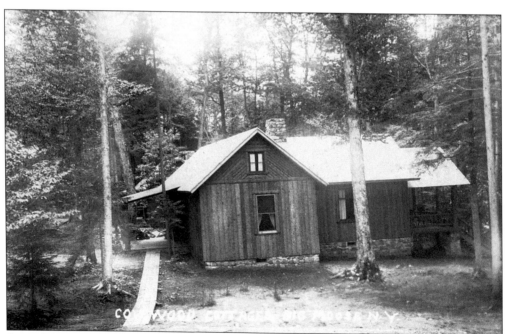

Several cottages were built to the west of the main lodge. Covewood is still in business today. The rustic character of the original design has been very well preserved.

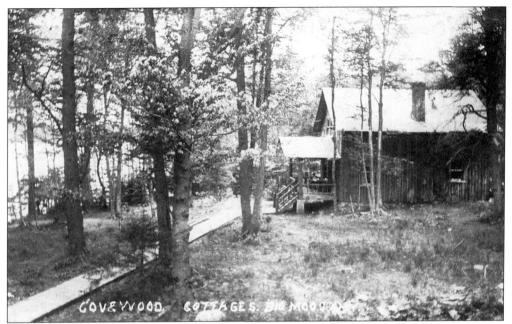

The cottages have been upgraded to housekeeping cottages. Covewood closed its kitchen and dining room and converted several upstairs rooms into housekeeping units. The second-floor porches have been enclosed and are now private sitting rooms.

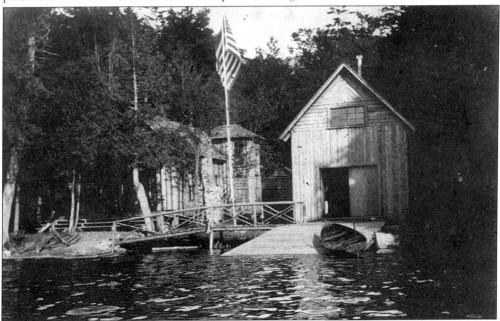

Just east of Covewood at the beginning of South Bay was Fern Spring Camp, one of the very earliest camps on the lake. Originally built for Mr. and Mrs. F.C. Moore of New York City, it was owned by Edward O. Stanley and his heirs for many years. Although this camp existed during the years that the steamboat operated, it was not served by the steamer since the water was too shallow for docking. All Fern Spring Camp buildings had been demolished by the 1940s, and the chapel manse now occupies this site.

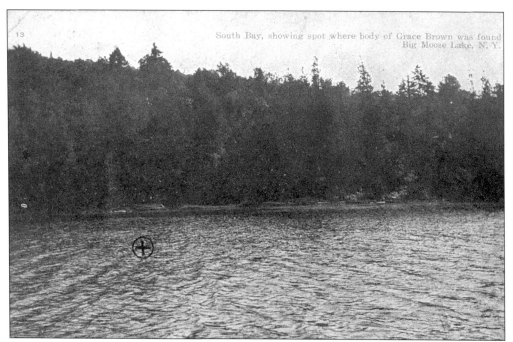

In the early years, there were no other camps in South Bay. The 1906 murder of Grace Brown in South Bay became national news, and numerous postcards referring to this crime were published.

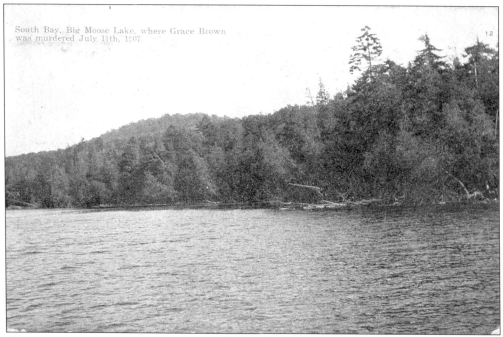

The caption on this card incorrectly stated that the murder was in 1907. This card was never used and was no doubt bought as a souvenir.

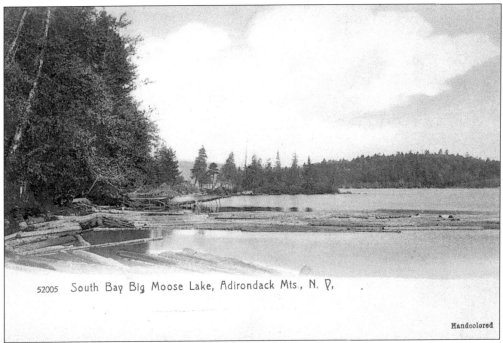

This postcard was not used and can be dated to before 1907, because one side is for the address only and the picture side has a wide margin for a message. In this view, cut logs can be seen floating in the water, suggesting that South Bay may have been a location of the logging activity mentioned on page 62.

Punkey Bay is a very small and attractive bay that opens into South Bay. It was mistakenly cited as the location of Grace Brown's murder.

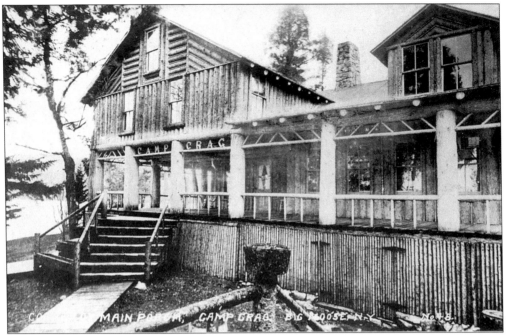

Camp Crag was one of the first camps on the lake; it was built before the railroad and steamboat were available to travelers. When steamboat service commenced, Camp Crag was a regular stop on the trip around the lake and was the next stop after Dart's Landing.

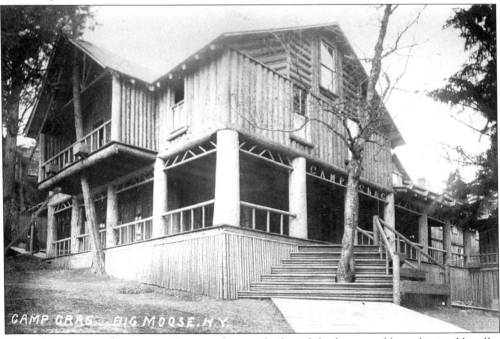

Camp Crag was another very rustic camp that was built with bark-covered logs obtained locally. Like so many of the very early rustic camps, Camp Crag consisted of several buildings, of which this main house was the largest. This structure evolved from the very first Camp Crag building, which was erected in 1886.

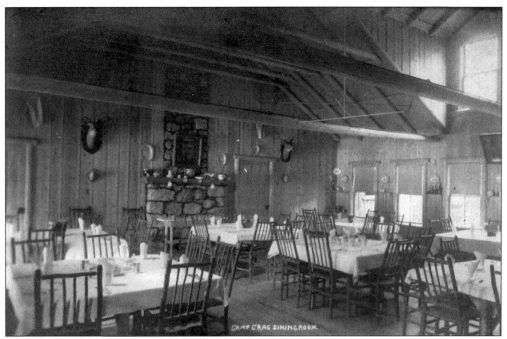

The dining room in the main camp was finished with naturally finished board and batten walls and peeled log beams.

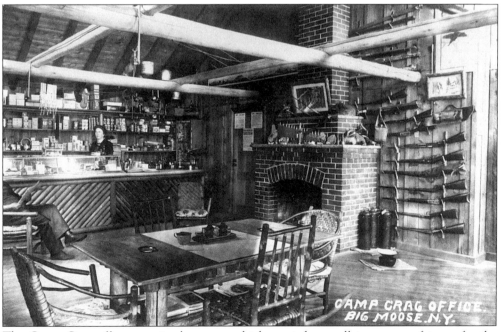

The Camp Crag office contained a store, which carried a small inventory of items for the convenience of guests and nearby camp owners.

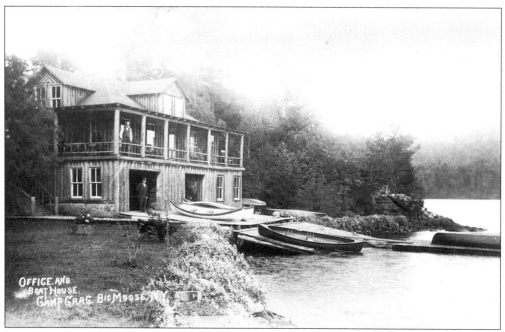

The Camp Crag boathouse was located at the very tip of Crag Point, facing the west. The boathouse and the main house have been gone for many years.

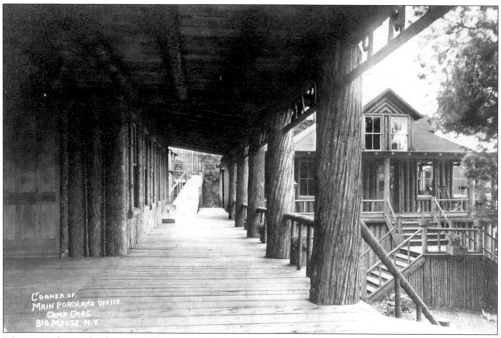

The main house had a typical large porch, as did the boathouse. The many buildings comprising Camp Crag were interconnected by the network of wooden walks pictured here.

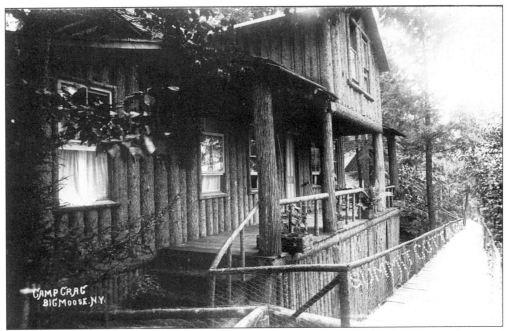

Summit Cottage, high above the water on the lake side of Crag Point, has been privately owned for many years. The plank walk interconnecting it with other camp buildings is long gone.

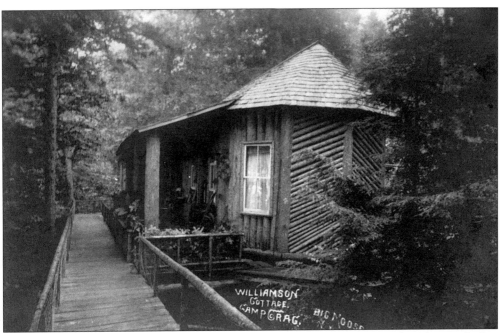

Camp builders often created decorative patterns in the bark-covered siding that they applied to camps. Sometimes the patterns were geometric shapes, such as diamonds, or as shown in Camp Crag's Williamson Cottage, an entire wall in which the siding is applied diagonally.

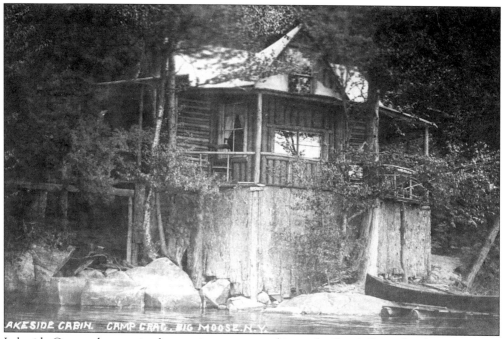

Lakeside Cottage has survived as a private camp and is on the South Bay side of Crag Point.

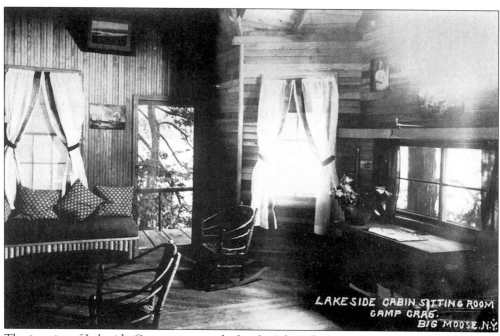

The interior of Lakeside Cottage is typical of early Adirondack camps.

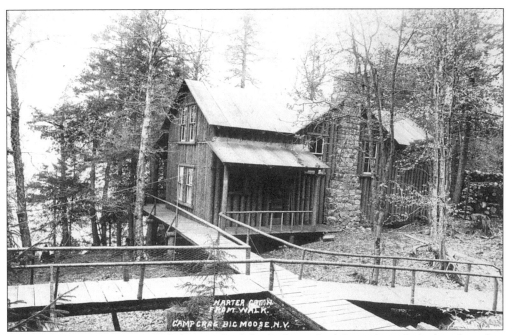

Like Summit Cottage, Harter Cabin was built high above the lake and was linked to the other camp buildings by the boardwalk. The lake is visible through the trees to the left of the cottage.

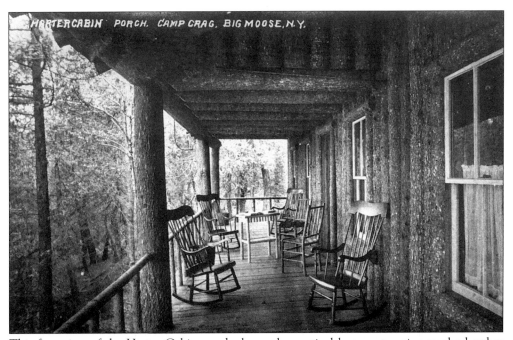

This fine view of the Harter Cabin porch shows the vertical-log construction method rather clearly. All exterior logs have been used without removing the bark.

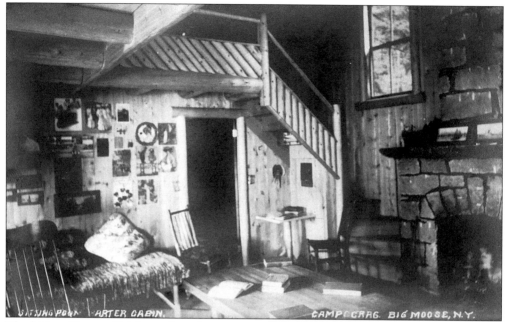

The high ceiling and high window placement in the Harter Cabin sitting room contributes to the brightness of the camp.

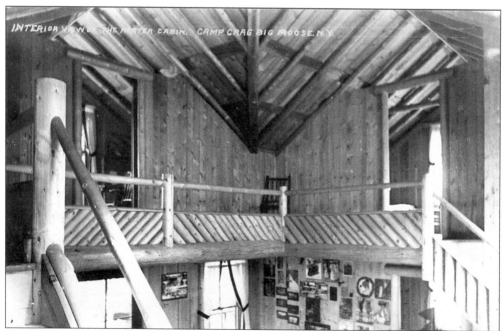

In this alternative view of Harter Cabin's interior, the unusual three-sided second-floor balcony is seen clearly.

Six
HIGBY CAMP

After leaving Camp Crag, the steamboat stopped next at Higby Camp, one of the very earliest camps on the lake.

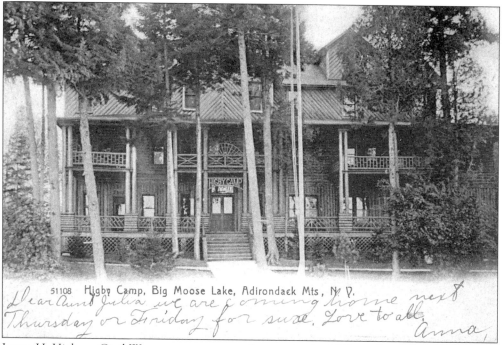

James H. Higby, a Civil War veteran, came to the area in the 1860s and established himself as a guide and camp builder. He soon opened Higby Camp, catering to parties of sportsmen and their guides. By 1900, when the building shown here was erected, the railroad had enabled travelers to reach the lake without the aid of guides, and Higby's clientele was starting to include more family vacationers and fewer sportsmen.

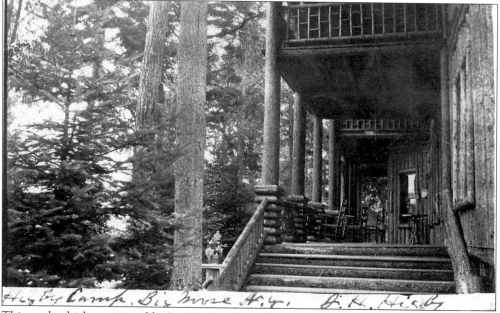

This card, which was signed by Jim Higby, shows the construction techniques (heavily reliant on native materials) and site selection (rustic structures discretely nestled into the existing forest) frequently encountered around the lake.

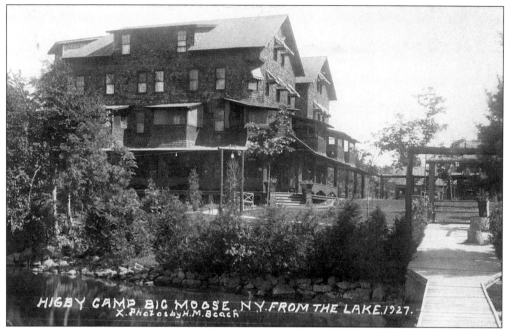

Higby's original main camp burned in 1921 and was replaced by this three-and-one-half-story, 80- by 160-foot structure.

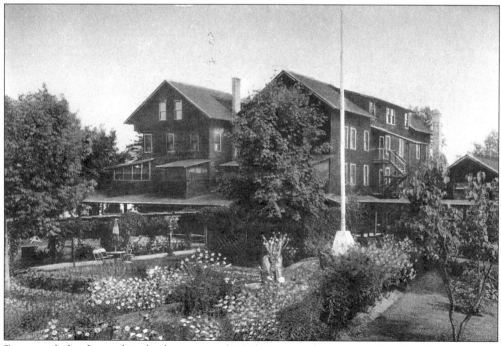

Extensively landscaped, indeed, manicured, Higby's catered to an upscale clientele.

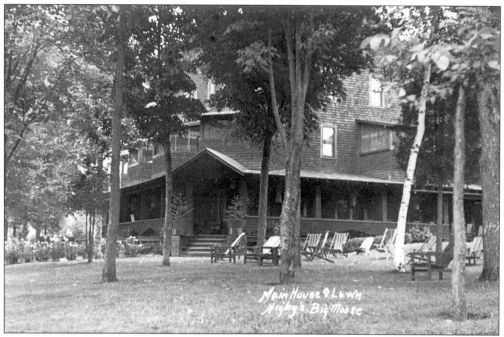

Higby's provided extensive and well-appointed areas for lawn sitting, as shown on this image, mailed in 1941.

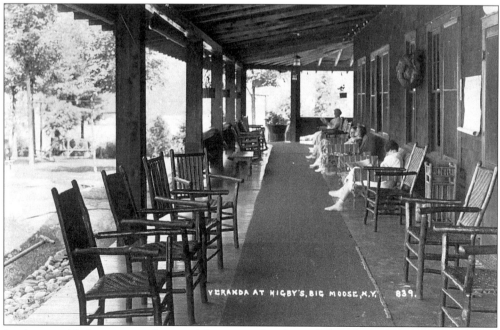

It also provided terrace and verandah sitting for those Adirondack days not suitable for unprotected outdoor entertainment of which, as any visitor knows, there are always a few.

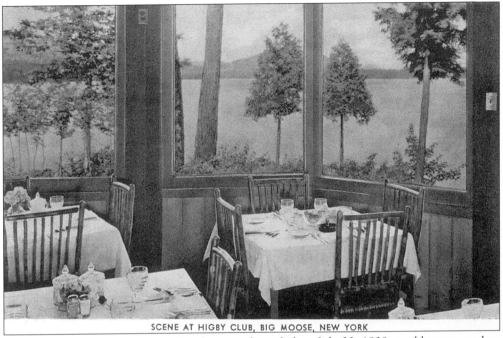

SCENE AT HIGBY CLUB, BIG MOOSE, NEW YORK

Higby's dining room, shown on the above card, mailed on July 23, 1939, could accommodate approximately 200 guests. Yet it was able to maintain, as shown below, an atmosphere both unpretentious and elegant.

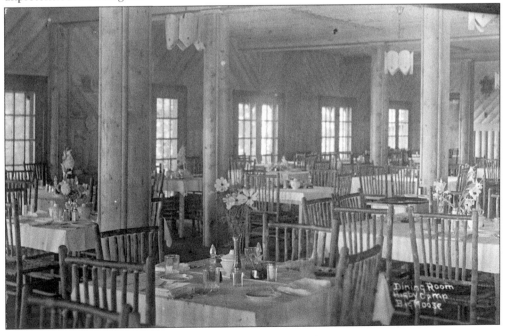

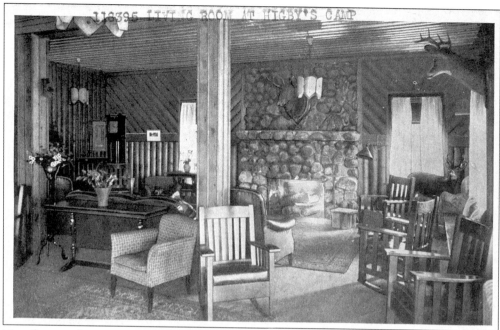

Very few comforts were overlooked at Higby's, including, much to the distress of Roy Higby's mother, the introduction of a cocktail lounge, below, in 1936.

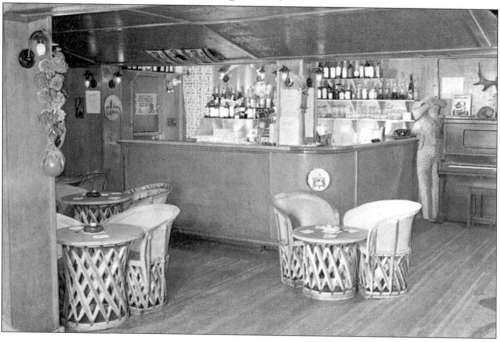

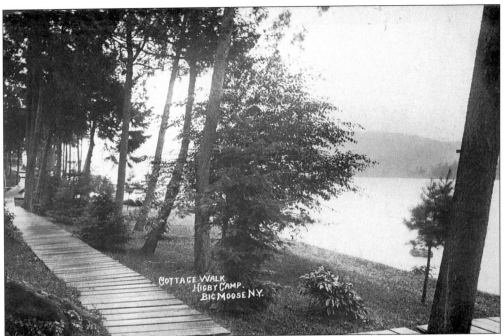

COTTAGE WALK
HIGBY CAMP.
BIG MOOSE N.Y.

As at all resorts around the lake, cottages were as attractive or more attractive to guests than the accommodations in the main camp. Both of these views look toward the west, with the lake on the right, and show the walkway to the Higby cottages from the main camp. Another popular feature of early Adirondack life were tented rooms, shown below, for sleeping out of doors.

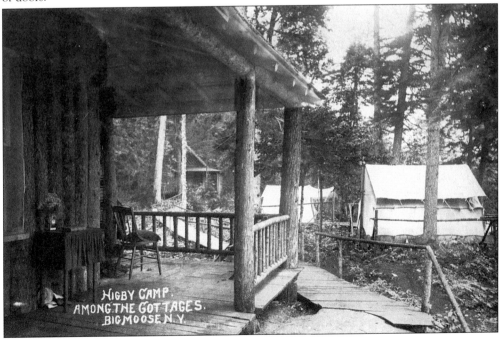

HIGBY CAMP.
AMONG THE COTTAGES.
BIG MOOSE N.Y.

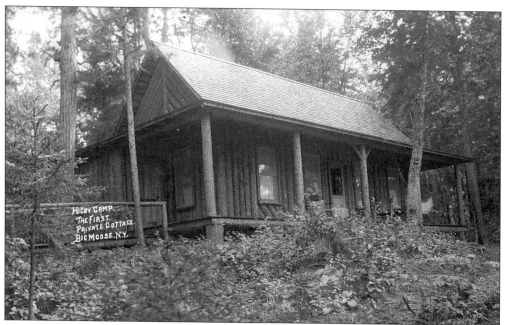

Starting modestly, this cottage was the first built for guests.

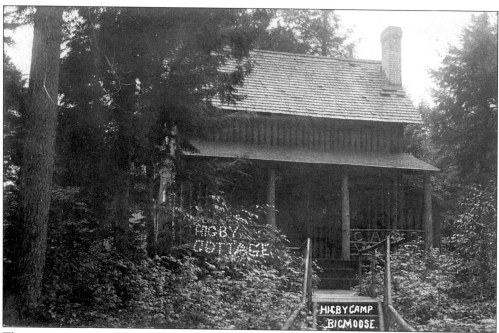

The eponymous Higby Cottage at Higby Camp probably confused the first guests.

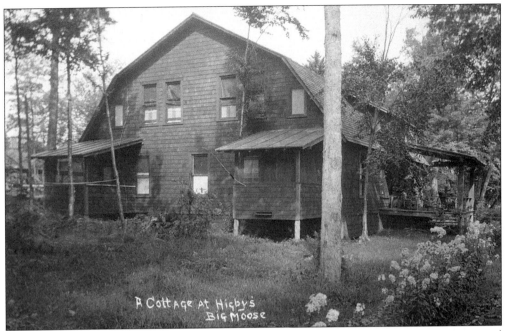

Ever grander, to suit the needs of guests often used to the best, Higby's cottages grew in size and sophistication over the years.

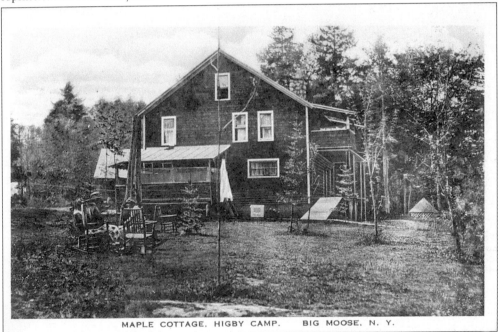

A number of the Higby cottages, including those on this page and the one preceding, took their names from local trees. The author of the preceding card, mailed from Darts Lake, notes that he "saw four deer this morning at 6:30 a.m."

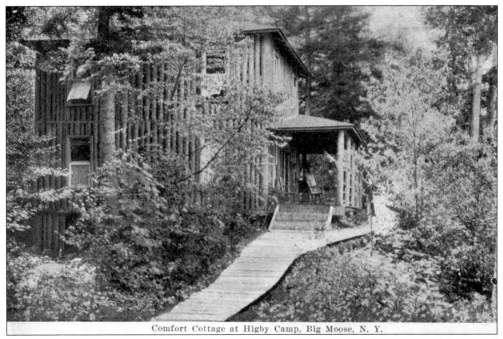

Comfort Cottage at Higby Camp, Big Moose, N. Y.

As the cottages got farther away from the main camp, they left behind the manicured lawns and evoked a more woodsy feel.

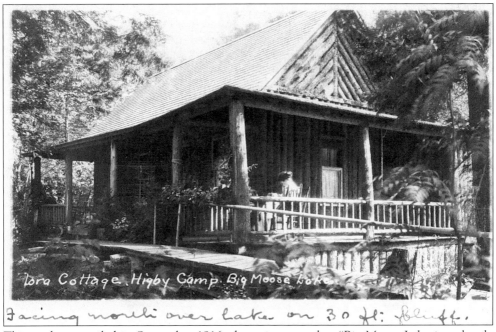

This card was mailed in September 1916; the writer says that "Big Moose Lake is as lovely as ever."

The message on this card could have been written today as easily as on June 27, 1939, when this card was mailed. It states: "We are finally having some nice days. The children love the water so much . . . it is hard for me to be lazy . . ."

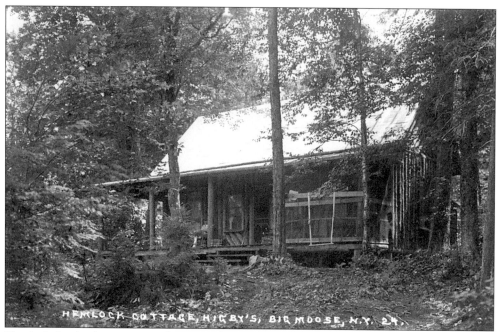

Nestled firmly but sensitively into the forest, Hemlock was truly representative of Adirondack cottages.

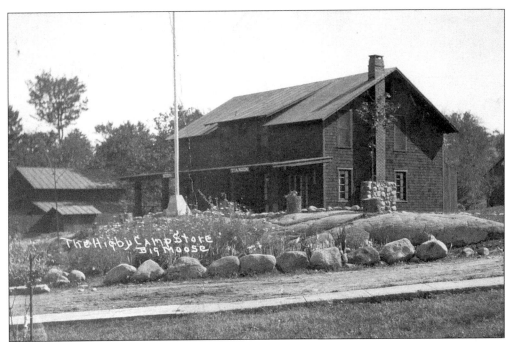

An important adjunct to life in the woods (as much as an hour's drive from the closest town, back in the 1940s and 1950s) was a general store. Higby's sold recreation equipment, warm clothing, and of course, snacks for children.

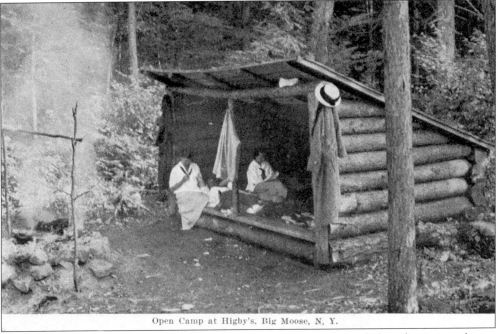

Big Moose open camps have been used for a myriad of activities, including daytime cookouts, as shown on this card postmarked September 21, 1926, and nighttime marshmallow roasts, a favorite of the author's children.

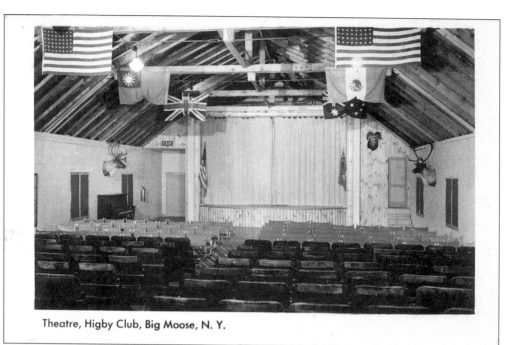

Theatre, Higby Club, Big Moose, N. Y.

Unique at Big Moose was Higby's sophisticated theater, used by professional and guest troupes alike. Postmarked September 16, 1952, this card was mailed by a woman who had come to Big Moose for the summer on May 13, 1952.

Upscale guests dressed for dinner, as they did at Higby's through the 1960s.

This image shows the nature of the earliest accommodations at Big Moose. Tents were common guest quarters from the 1860s through the 1890s.

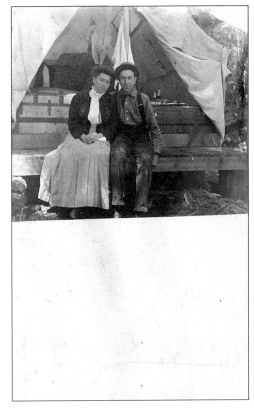

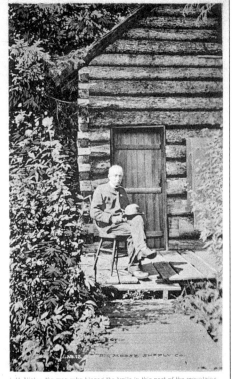

Sometime before 1892, Jim Higby (rightly a legend at Big Moose) poses here in front of the log cabin he built on land that later became the Higby Camp.

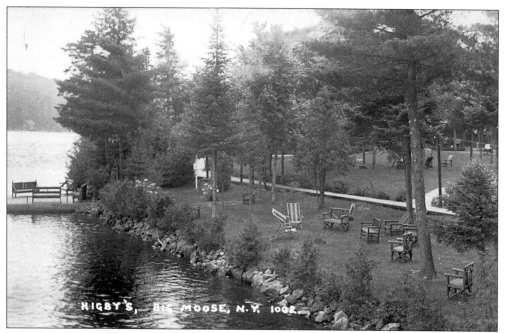

More than most of the other Big Moose camps, Higby's provided both considerable "tamed" outdoor space and organized activities.

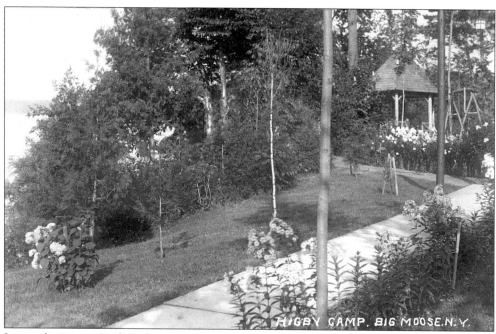

In another view, Higby's demonstrates its continuing commitment to providing a virtually estate-quality environment.

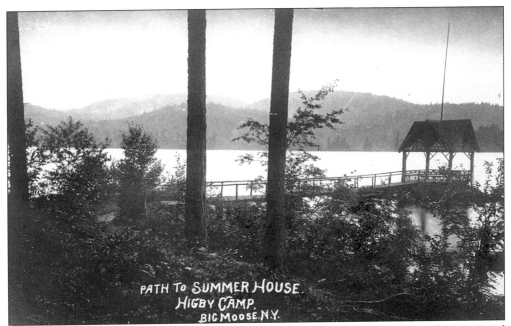

The Higby Camp had several summerhouses. This one, located at the water's edge, was used day and night for quieter activities that could draw on the magic of being largely surrounded by the lake.

Being relatively small, this hexagonal summerhouse tended to encourage reflection, especially in the late hours when the sky was full of stars enhanced by the darkness of an Adirondack night.

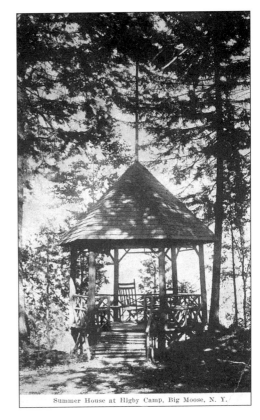

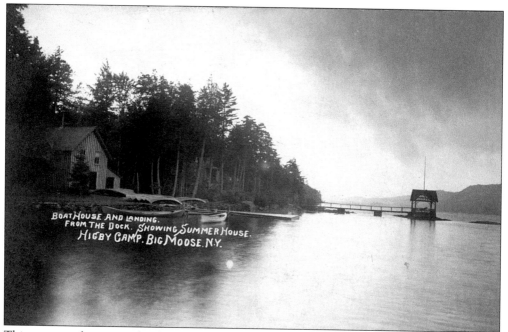

This very early postcard of the Higby waterfront was postmarked July 26, 1909. The summerhouse, the same one that appears at the top of page 93, was built on a large offshore rock.

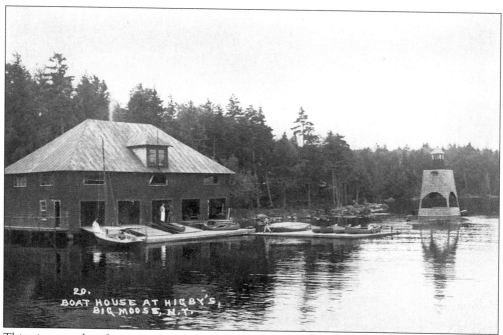

This picture, taken from approximately the same location as the one above, shows that a newer and larger boathouse has replaced the previous one and that a new shingled summerhouse with a lighthouse top has replaced the original rustic summerhouse. The boathouse and summerhouse are both gone today, but the large summerhouse rock is still visible in the water and is marked as a hazard to boaters.

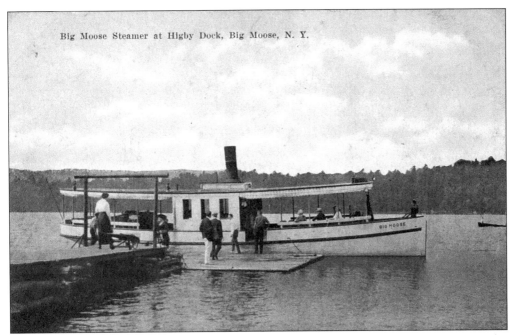

Every day, the steamer brought guests, supplies, and, perhaps most importantly for guests who commonly stayed for months, the mail.

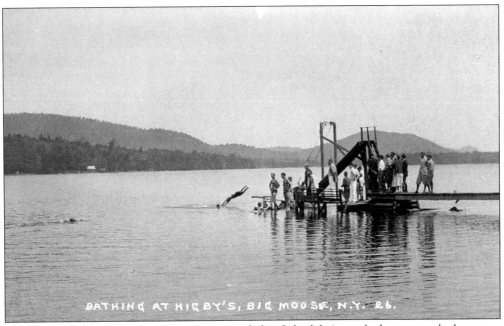

This view, which nicely shows the mountains behind the lake's north shore, reveals that some things just don't change: children still like to swim.

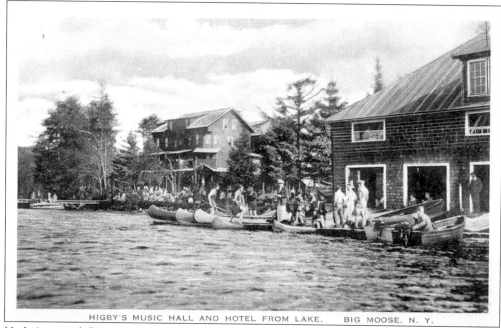

HIGBY'S MUSIC HALL AND HOTEL FROM LAKE. BIG MOOSE, N. Y.

Higby's second-floor music hall was often used by younger guests and visitors from around the lake for dancing and other activities that parental eyes might not have fully appreciated.

This later postcard shows the swimming area that was developed by Higby's on the bay side of the point.

Seven
From VanderVeer's to North Bay

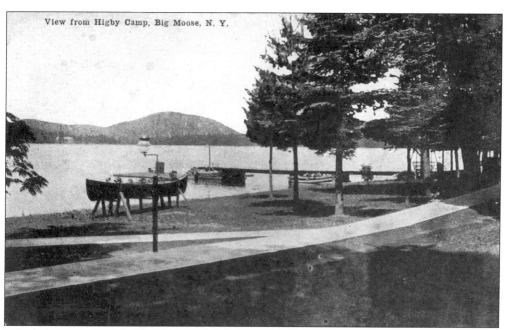

When the steamboat left Higby's, it headed east in the direction seen above and continued along the south shore. Visible in the distance is Mount Tom. Visible on shore is a guide boat made into a flower planter; the boat had probably been damaged somehow and judged not worth repairing.

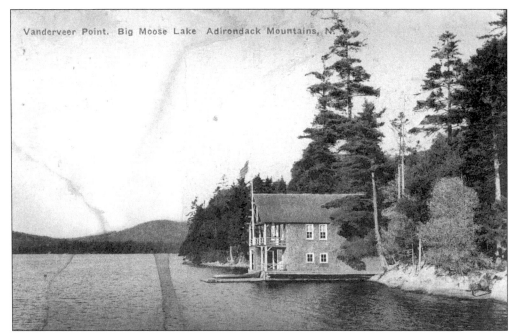

Dr. Albert VanderVeer of Albany was an early Big Moose Lake camp builder. His camp was built on the south shore, east of the Higby Camp, and is still in the VanderVeer family today. The boathouse is still in use and has not changed noticeably since this postcard was sent in 1928. VanderVeer's camp was a scheduled stop on the steamboat route.

VanderVeer's original camp building, seen here, burned many years ago. Today, there are two camps on the property, but neither is on the site of this original structure.

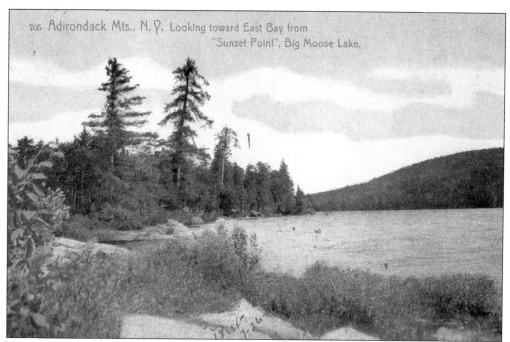

Beyond the VanderVeer camp is the beginning of East Bay. This 1908 view looks east from the rocky point of land that extends out into the lake and which was named Sunset Point, surely after the fine views of the sun setting over the other end of the lake. The steamboat stopped at the camp of A.J. Williams, a very early camp located on this point.

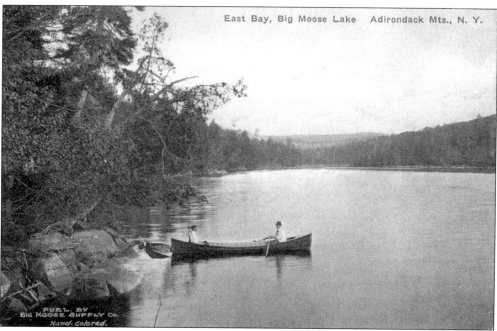

A traditional Adirondack guide boat is pictured along the north shore of East Bay in this 1927 postcard. When carrying two people, these boats are rowed from the bow, as seen here.

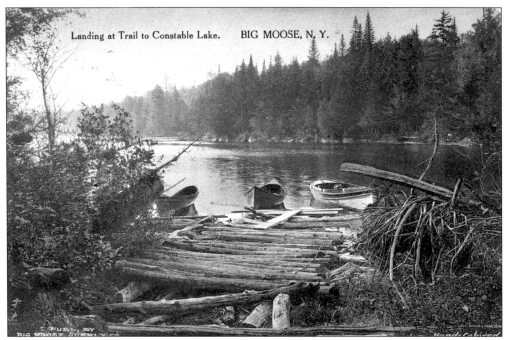

A trail to Constable Pond originated from the very end of East Bay. This trail fell into disuse as roads were built in the Big Moose area and new trails originating from trailheads along these roads were created.

A Boy Scout camp operated for quite a few years at the same point where the landing for the trail to Constable Pond had existed.

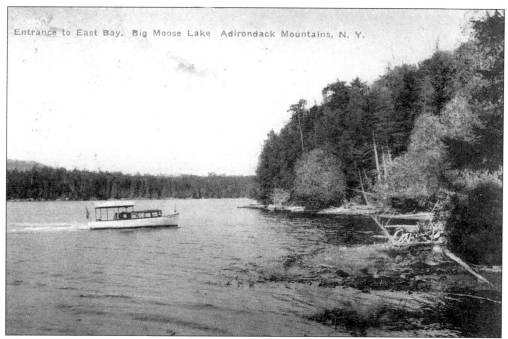

This card postmarked in 1929 shows the pickle boat traveling along the south shore at East Bay.

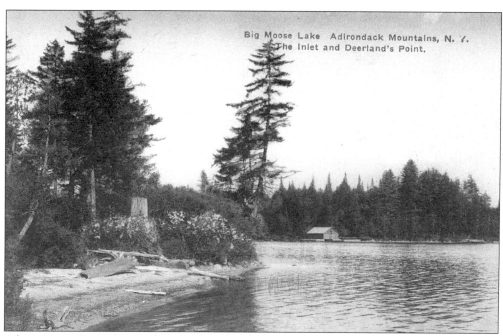

After passing Sunset Point, the steamboat headed across the eastern end of the lake toward the north shore, passing the entrance to the marsh, which is also the inlet to the lake. Adjacent to the marsh entrance was Deerlands Camp. This view from the north shore shows the Deerlands Camp boathouse.

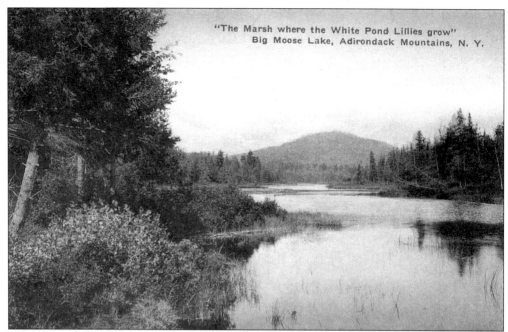

The marsh was a popular destination for boaters who enjoyed the many water lilies. The marsh has always been a good spot for viewing wildlife.

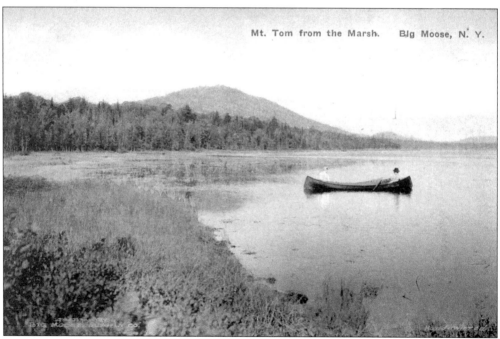

Three trails to wilderness ponds originated from along the shores of the marsh. The trails to Gull Lakes and Sisters Lakes continue to be maintained by the Adirondack Park. The old trail to Russian Lake from the marsh was abandoned years ago.

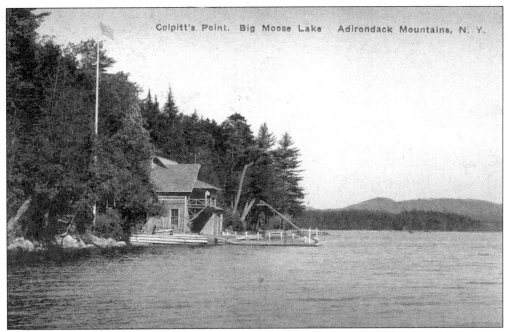

The steamboat turned west along the north shore and stopped at several camps. The Swancott Camp that was named on the steamboat ticket shown on page 11 was built before 1904 and was later acquired by the Colpitts family. This postcard of the camp's boathouse from the Colpitts years carried the following message: "This is the boathouse of one of the wealthiest people on the Lake. I was called here one night to take care of a young boy threatened with pneumonia. Quick treatment saved him. Had the thrill of going on a case in a motor boat."

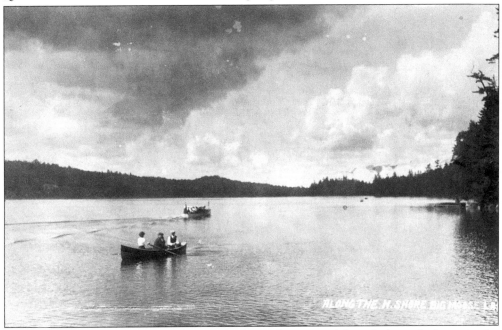

This view looking west along the north shore shows an Adirondack guide boat in the foreground and a motor launch beyond.

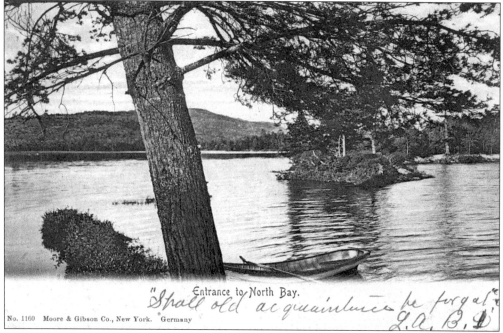

This 1906 postcard shows the entrance to North Bay from the lake, at the right in the picture. The well-known narrow and shallow passage into North Bay becomes considerably enlarged, as shown, during the infrequent periods of very high water that sometimes occur in the spring.

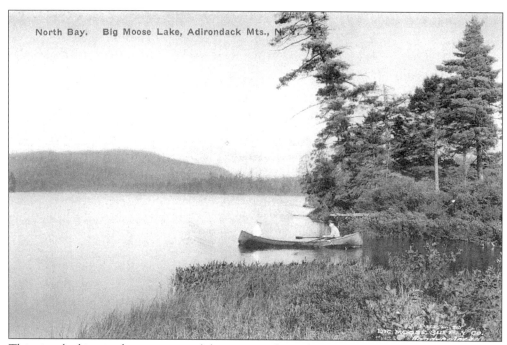

This view looking in the same general direction as above shows more of the bay. The guide boat is about to pass from North Bay into the lake, which is to the right. The picture was taken from the easternmost point on the Waldheim property.

Eight
BROWN'S TO MARTIN'S

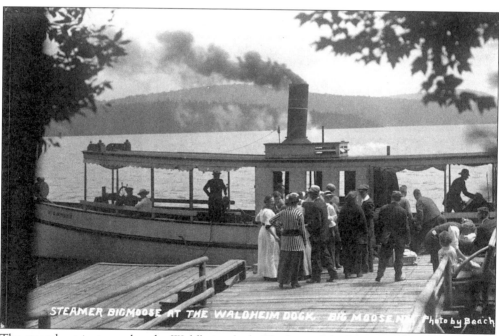

The steamboat is stopped at the Waldheim dock. The bow of the boat is to the left, where the ship's wheel is visible. Baggage was customarily carried aft; on the right, a crewman handles a trunk in the stern of the boat. On the dock Edward "E.J." Martin, builder and proprietor of the Waldheim, leans over the bench, apparently handling a mailbag. The boat was equipped with roll-down canvas sides, which were lowered in inclement weather. Passengers preferred to ride in the bow to have fresh air while traveling rather than risk being exposed to coal smoke from the boiler, which drifted to the rear once the boat was under way.

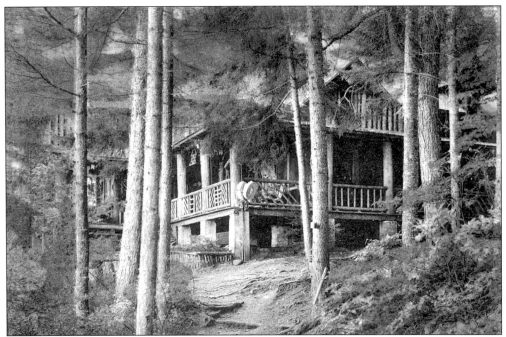

In February 1901, before there was a Waldheim, Leslie W. Brown of Utica purchased property at the entrance to North Bay. Later that year, E.J. Martin and his crew built this beautiful camp for Brown, and it became a stop on the steamboat route.

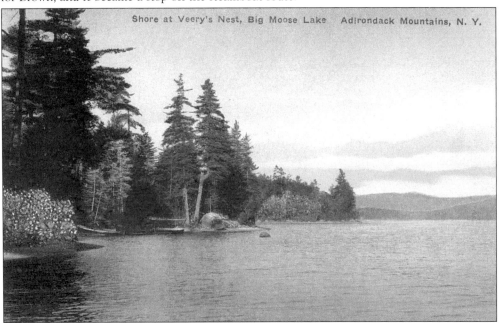

In 1920, Leslie Brown sold the camp and his large North Bay holdings to Charles Williams, who sold the camp area to a Mr. Tipson in 1921 but kept and lumbered the North Bay property. Tipson sold his property to Frank Naporski, who operated it as a small resort named Veery's Nest. The camp burned in 1929 and Martin foreclosed on his mortgage in 1935, integrating the camp into the Waldheim.

In 1901, E.J. Martin purchased the 12 lots just west of Brown's, which eventually became the Waldheim, or "Home in the Woods." This is the original boathouse.

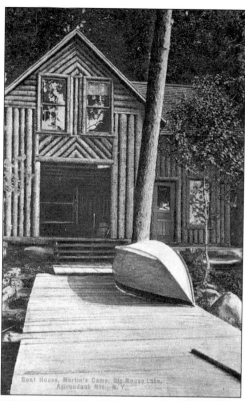

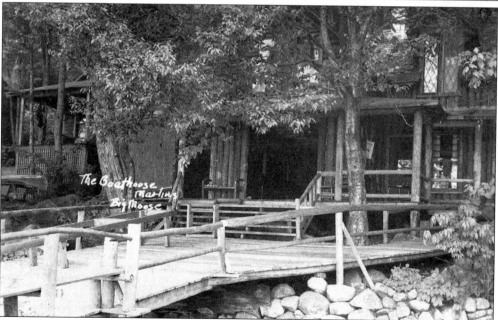

The Waldheim opened for business with the Martin brothers E.J. and Charles Martin as proprietors in 1904. By 1906, E.J. Martin was in business alone. This is the same boathouse as show above, enlarged over the years to encompass the camp office, a library, and an upstairs apartment.

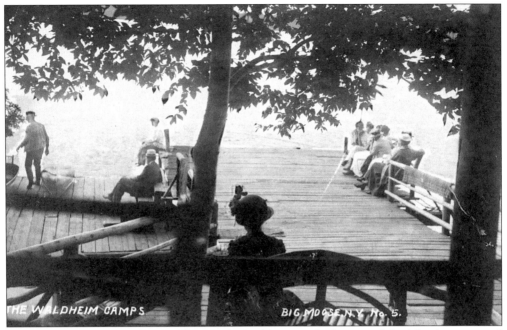

For more than nine decades, Waldheim's docks, like most docks around the lake, have invited guests to sit and socialize.

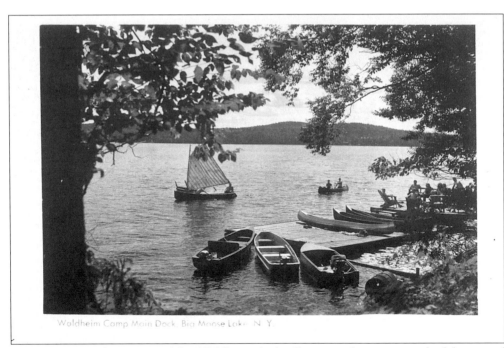

This later view of a portion of the Waldheim dock offers a good view across the lake toward Lake View Lodge. The card was mailed in September 1948.

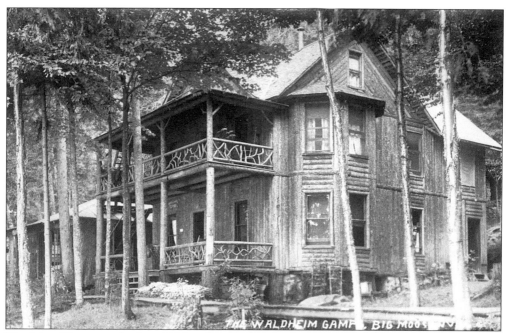

The Main House was built c. 1902 and opened for business in 1904. The first guests were Maj. Gen. George C. Davis, the governor general of Panama, and his family, who stayed for the whole summer.

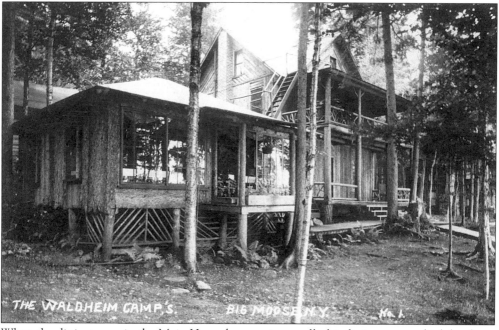

When the dining room in the Main House became too small, this dining room, which has been enlarged twice since then, was built in 1909. It now seats some 80 guests.

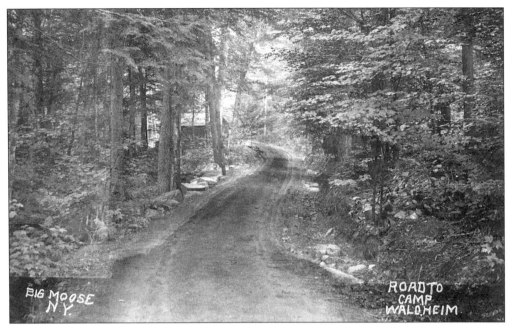

At the outset, the only entrance to Waldheim, as with many of the camps, was by boat. With the advent of the automobile, however, the back door became the front door. This view looks west on Martin Road from the camp parking area.

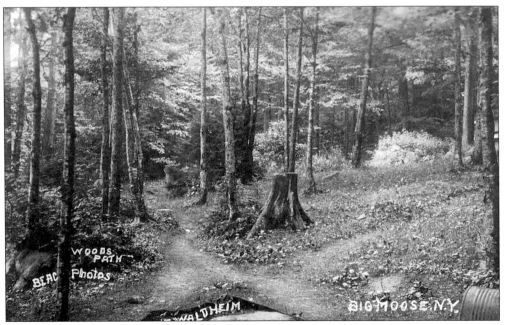

At most Adirondack camps, walking is not optional; likewise, at Waldheim, where guests spend many hours walking trails, which have remained largely unchanged over decades. The message on this card, postmarked August 10, 1936, complains that "two weeks is far too short a stay in this lovely spot," a sentiment with which the authors heartily agree.

After leaving the main dock and passing by the dining room and the main house, a boardwalk, replaced by concrete in the 1930s, leads to the 15 cottages that comprise the camp.

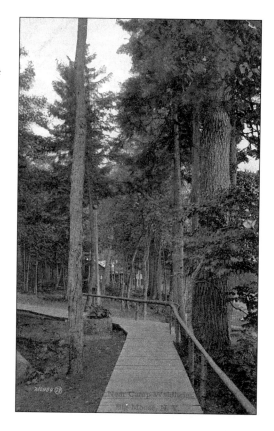

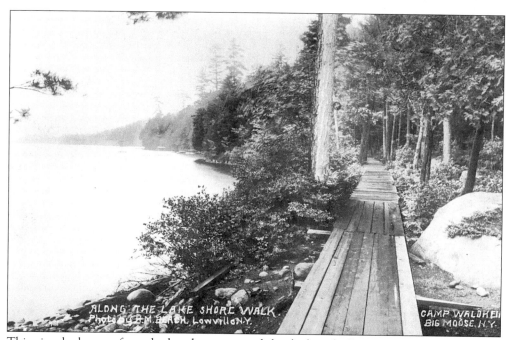

This view looks west from the beach area toward the dock and office.

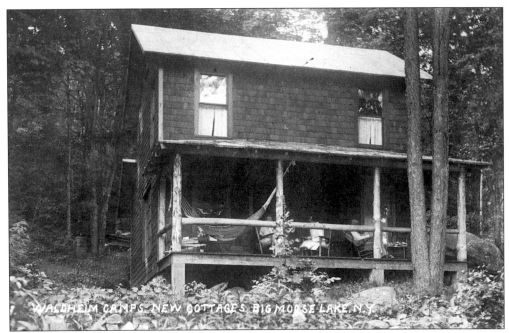

Originally three small rooms, this was the first home of E.J. and Hattie Martin in January 1902. It was later used as the camp laundry and was enlarged in 1925, when the present laundry was built. It was aptly named Casa Prima.

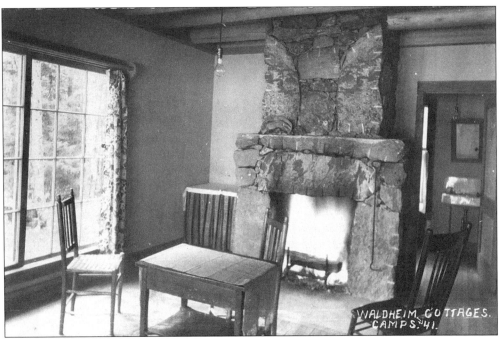

All Waldheim cottages share large stone fireplaces and much furniture that was built by E.J. Martin. In 1925, however, Casa Prima was rather sparsely furnished.

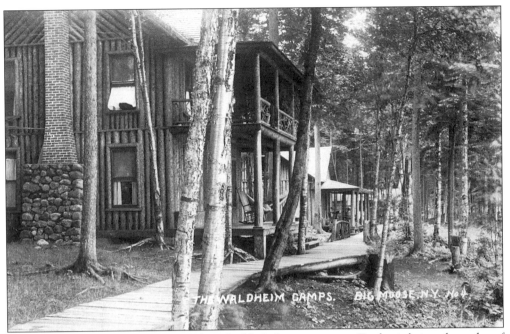

June Cottage is one of Waldheim's four double-balcony cottages. Fresh air being the order of the day, people often slept on cots on the upper porches.

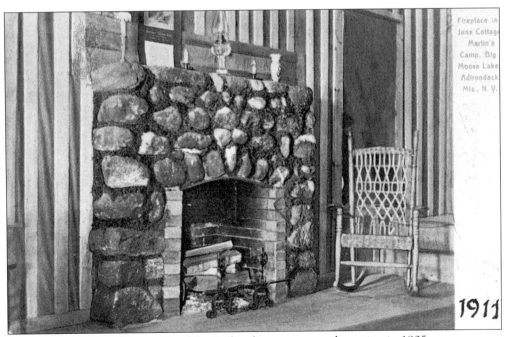

June Cottage, warmed by another Martin fireplace, was up and running in 1905.

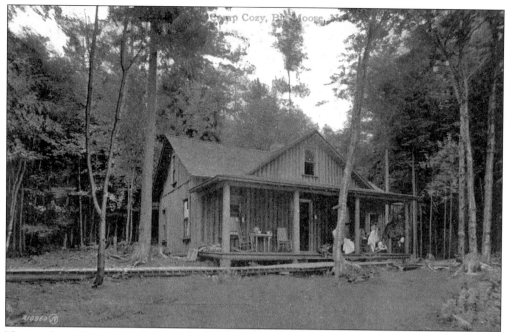

Next to June Cottage on the boardwalk was Cozy Cottage, all ready for the 1906 season.

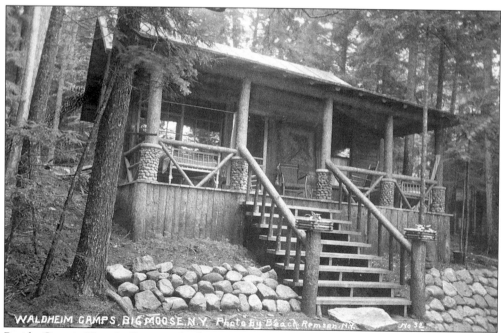

Beside Cozy is Heart's Content, built prior to 1920 and named by Julia Sanderson, a well-known singer of the time. Notice the cots out on the porch and the curtains on a wire that can be drawn around the cots for privacy while sleeping. This card was postmarked August 5, 1933.

Everett Cottage, next in line on the Waldheim path, is named for one of E.J. Martin's two sons. Everett Martin and the cottage both arrived in 1909.

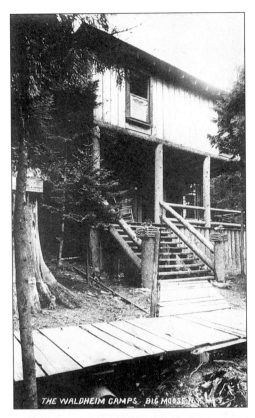

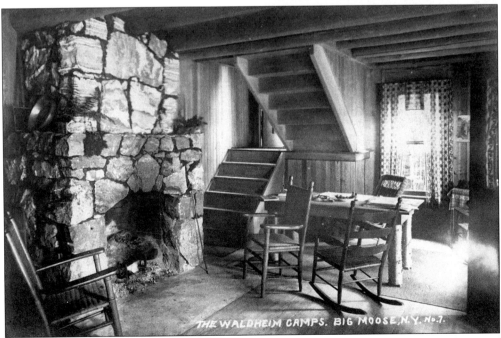

This card mailed in August 1918 shows the interior of Everett Cottage, a balance of sophistication in construction technique and rustic comfort.

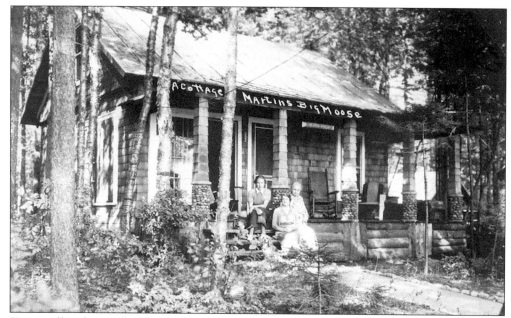

Two small and virtually identical cottages were built in the early 1920s to replace tents, which had been used for several years: Woodbox, shown above on a card mailed in 1952, and Fireplace. They flank a fire access road to the lake. The message on the lower card says, "know you'd enjoy some time just sitting here. Of course, you have to walk a little to manage the next meal," which is as true today as it was in 1941, when the card was mailed.

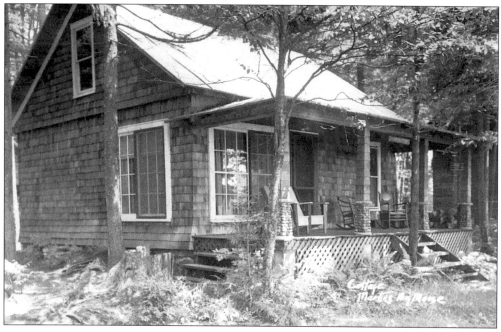

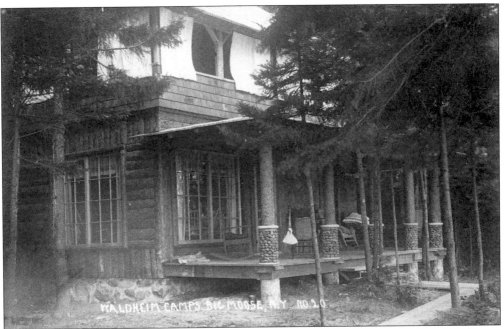

The concrete walk ends directly at Comfort porch, once called "Happy Thought," according to a card used by E.J. Martin's wife, Hattie Martin. Notice that the second-floor bedrooms are not enclosed but have canvas sides, which can be drawn closed in inclement weather or opened for sleeping in the fresh mountain air.

An open camp is an Adirondack necessity. This one, long gone, was located near the beach at the then east end of the property. Today, the Waldheim is as dynamic as it was in 1904. Indeed, in 2000, a new guest cottage was being built by E.J. Martin's granddaughter and her husband.

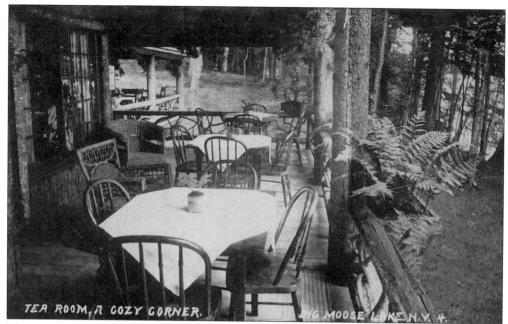

This camp, west of the Waldheim, was built for a Dr. Koller. In 1908, Koller sold it to Warren Richards, whose name appears on the ticket on page 11 and who for a few years operated the camp as a resort named Idle Wild. In 1911, Richards sold the camp to Charles Martin, E.J. Martin's brother. Alice Martin, Charles Martin's wife, ran the tearoom pictured here. The structure, which is still standing, closely resembled the L.W. Brown camp shown on page 106.

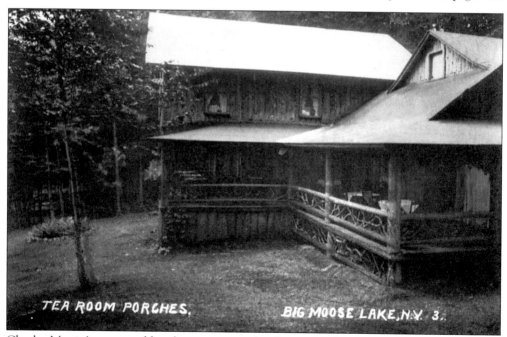

Charles Martin's camp and boathouse were used to house overflow guests from the Waldheim. It was only a short walk or paddle to Waldheim's dining room. The message, "This is a wonderful place and we have lots of fun," is dated July 17, 1923.

Nine
Returning to the Landing, Odd Lots

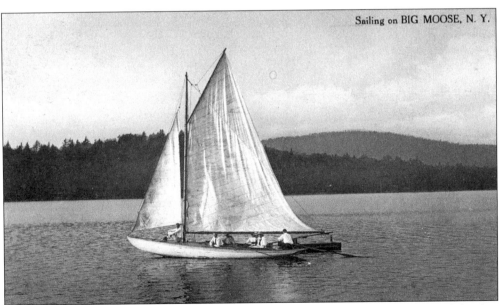

This 1919 postcard shows a gaff-rigged wooden sailboat that is typical of sailboats of the day. White shirts and ties are apparent, indicating vacationers were reluctant to give up their more formal attire, even on vacation.

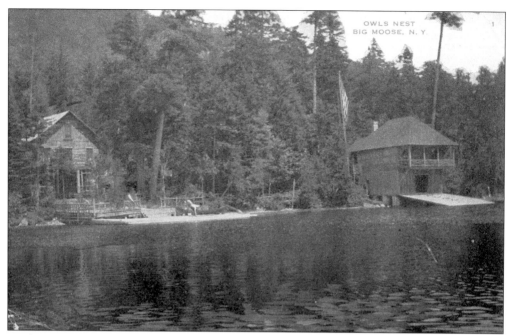

Farther along on the north shore, the steamboat stopped at Owl's Nest, a private camp. This camp exists today and has not changed significantly in the 90 years since this postcard was sent.

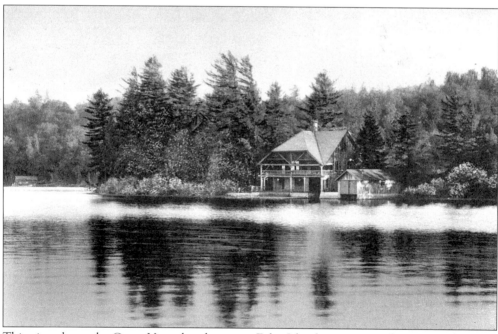

This view shows the Camp Veery boathouse on Echo Island as it appeared in 1941, when this card was mailed to Poughkeepsie. The camp's main house was hidden then, as it is today, by the shorefront trees. The camp was owned through the 1920s by Minnie Maddern Fiske, a renowned stage actress. Visible at the extreme left of the picture is a small boathouse across the lake, where the Lake View launch was kept.

This small teahouse was operated for several years by the wife of David B. Milne, a prominent Canadian artist of the period. It was located on the north shore of West Bay and, at the time, there was a trail running along the north shore waterfront from the Glennmore to the Waldheim. Not surprisingly, the teahouse became a convenient place to stop for refreshments and rest.

ENTRANCE. "THE LITTLE TEA HOUSE." BIG MOOSE LAKE, N. Y.

LANDING. "THE LITTLE TEA HOUSE." BIG MOOSE LAKE, N. Y.

The teahouse was located close to the water, which made it convenient for guests to arrive also by boat. This building exists today as a private camp, accessible from the Martin Road.

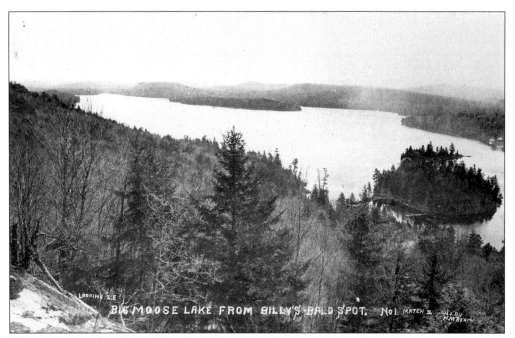

This postcard, taken from Billy's Bald Spot, was designed to match up with the card on the facing page to give a complete view of the lake. In the center of the card, Crag Point shows prominently across the lake. At the right, Echo Island shows clearly and on the island, portions of the Camp Veery main house and boathouse are visible.

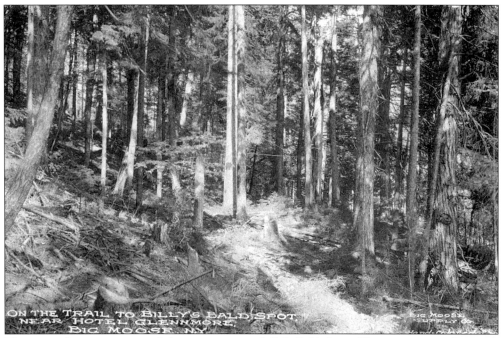

This view shows a portion of the ascent up to Billy's Bald Spot. The message on this card, mailed to Hartwick, New York, on November 5, 1923, says: "We are in the same old spot having a good time. Not but a little snow."

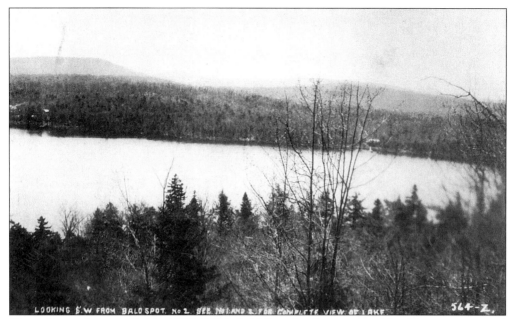

Since this card was mailed in 1919, Billy's Bald Spot has become considerably overgrown and it is no longer possible to see as far down the lake. Burdick's Camp can be seen across the lake behind the tall trees in the foreground. On the far left, Lake View Lodge and boathouse appear across the lake, at the point where the two cards meet.

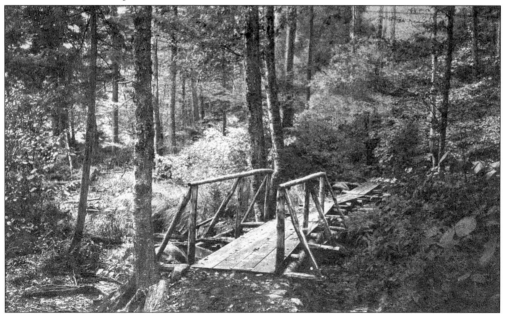

The trail to Billy's Bald Spot, high above West Bay, is one of the oldest trails in the area. This trail originated at the water's edge near Echo Island and intersected the shoreline trail. The pictured bridge is believed to have been on the shoreline path, where it would have been crossed by Glennmore guests on their way to the Billy's Bald Spot trail. The trail to Billy's, which has long been privately owned and maintained, continues to be a popular destination for visitors.

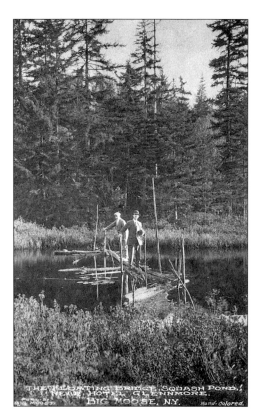

The trail to Billy's Bald Spot continued a short distance to Squash Pond. No camps or buildings of any kind were ever built at Squash Pond, and why the floating bridge pictured here was ever built remains a mystery. As in previous pictures, these men are rather formally attired in white shirts, jackets, ties, and derby hats; they no doubt consider themselves properly dressed for a hike in the woods.

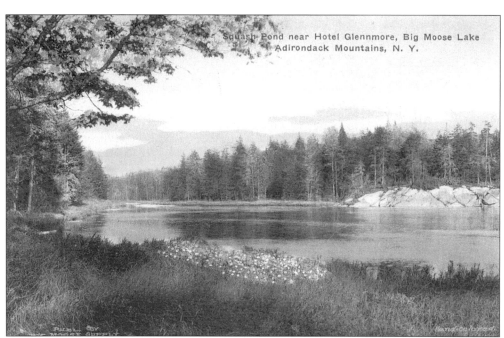

Squash Pond was a wilderness pond frequented by summer hikers seeking beauty and solitude, fall hunters seeking venison, and winter trappers seeking pelts.

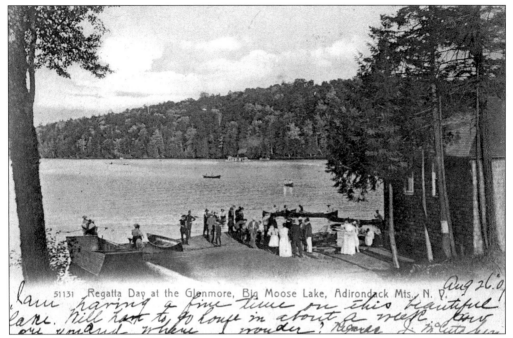

Regatta Days have been held for as long as anyone can remember. This card, mailed in 1907 to Rehoboth, Delaware, shows a group of people at the landing but surprising little activity on the water.

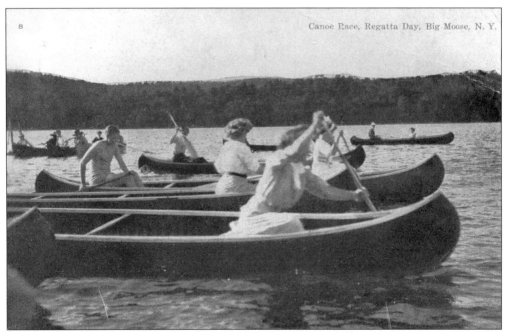

This card, sent in 1911, is more illustrative of Regatta Day activities.

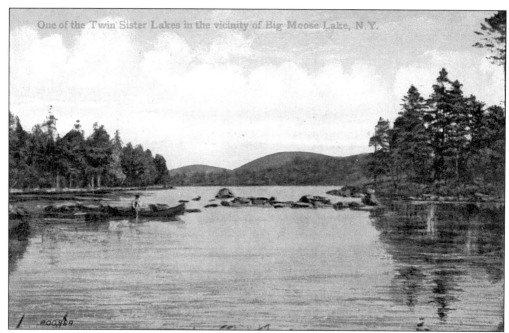

Numerous other wilderness ponds in the Big Moose area have long been popular hiking destinations. The Sisters Lakes, shown in this 1908 card, can be reached from a trail beginning at the eastern end of the marsh. It seems remarkable that someone would lug the bulky photographic equipment of the day over several miles of woodland trails just to produce a postcard.

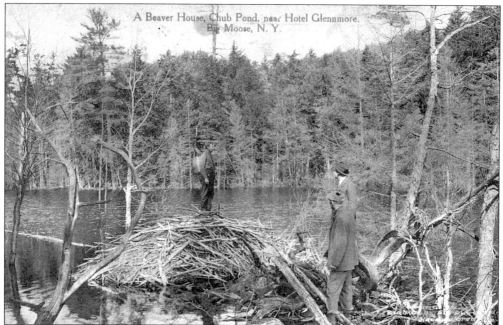

Chub Pond is another area wilderness pond that has been popular with hikers for years. The beaver lodge shown here is of impressive size and no doubt helped attract hikers, as well as sell postcards.

The apparent absence of wind made it relatively easy for these sailors to pose for the photographer. The view looks east with Mount Tom in the background. As has been frequently noted, these people are rather formally, and perhaps inappropriately attired for a day of sailing, at least by the standards of today.

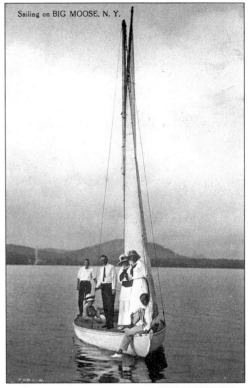

Pancake Hall dates to the very earliest years of Big Moose settlement. It was located close to the water on the north shore between the Waldheim and Echo Island at a spot where a small stream comes down the hill to the lake. It was a popular place for group campfires and appeared on hiking maps for years.

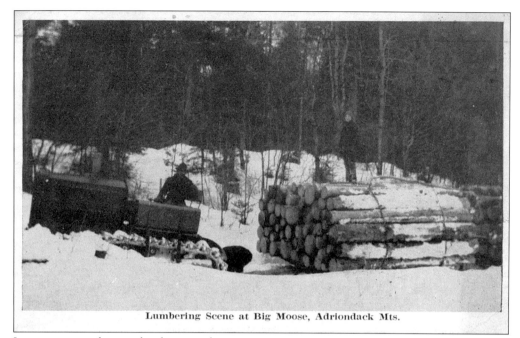

Lumbering Scene at Big Moose, Adriondack Mts.

Logging was a substantial industry in the Big Moose area and continues even today. In this view from 1921, tractors have replaced horses for towing sleds of logs to the railroad for shipment to paper mills or sawmills.

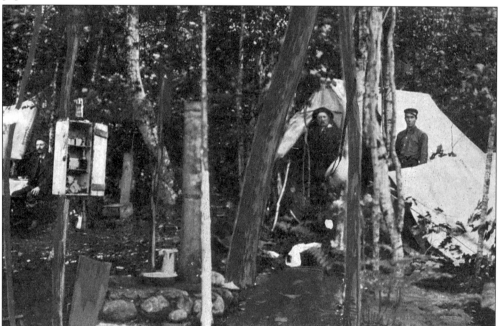

The caption on this card is difficult to read but can be made out to say: "An Adirondack Camp, Big Moose, N.Y." For many years, guides brought parties of sportsmen to the Big Moose area for fall hunting and spring fishing. This is likely a fishing camp because a creel hangs from a tree, the sportsmen are using tents, and the trees still have leaves. None of these would be expected in a view of a fall hunting camp.